NICOLAS BOURRIAUD
POSTPRODUCTION
CULTURE AS SCREENPLAY: HOW ART REPROGRAMS THE WORLD

LUKAS & STERNBERG, NEW YORK

Nicolas Bourriaud

Postproduction

Publisher: Lukas & Sternberg, New York

© 2002 Nicolas Bourriaud, Lukas & Sternberg 1005359558

First published 2002 (978-0-9711193-0-7)

Reprinted with new preface 2005

Reprinted 2007

Editor: Caroline Schneider

Translation: Jeanine Herman

Copy Editors: Tatjana Günthner, Radhika Jones, John Kelsey

Design: Sandra Kastl, Markus Weisbeck, surface, Berlin / Frankfurt am Main

Printing and binding: Druckerei Otto Lembeck, Frankfurt am Main

ISBN 978-0-9745688-9-8

Lukas & Sternberg is an imprint of Sternberg Press.

Sternberg Press

Caroline Schneider

Karl-Marx-Allee 78, D-10243 Berlin

1182 Broadway # 1602, New York, NY 10001

mail@sternberg-press.com, www.sternberg-press.com

CONTENTS

PREFACE TO THE SECOND EDITION

Since its initial publication in 2001, *Postproduction* has been trans-
lated into five languages; depending on the translation schedules in
various countries, publication either overlapped with or preceded that
of another of my books, *Esthétique relationnelle* (Relational Aesthetics),
written five years earlier. The relationship between these two theoret-
ical essays has often been the source of a certain misunderstanding,
if not malevolence, on the part of a critical generation that knows itself
to be slowing down and counters my theories with recitations from
"The Perfect American Soft Marxist Handbook" and a few vestiges of
Greenbergian catechism. Let's not even talk about it.

I started writing *Relational Aesthetics* in 1995 with the goal of finding
a common point among the artists of my generation who interested
me most, from Pierre Huyghe to Maurizio Cattelan by way of Gabriel
Orozco, Dominique Gonzalez-Foerster, Rirkrit Tiravanija, Vanessa
Beecroft, and Liam Gillick – basically, the artists I had assembled in
an exhibition called *Traffic* at the CapcMusée d'art contemporain in
Bordeaux (1996). Each of these artists developed strangely similar
themes, but they were not a topic of real discussion, since no one at
the time saw these artists' contributions as original and new. In search
of the common denominator, it suddenly occurred to me that there
was a new thematic framework for looking at their works. I realized that
every one of them without exception dealt with the interhuman sphere:
relationships between people, communities, individuals, groups, social
networks, interactivity, and so on. In its time, Pop Art was born of a
conjunction between the phenomenon of mass production and the
birth of visual marketing, under the aegis of a new era of consump-
tion. *Relational Aesthetics* was content to paint the new sociopolitical
landscape of the nineties, to describe the collective sensibility on
which contemporary artistic practices were beginning to rely. The suc-
cess of this essay, which – alas – has at times generated a sort of cari-
catured vulgate ("artists-who-serve-soup-at-the-opening," etc.), stems
essentially from the fact that it was a "kick start" to contemporary

aesthetics, beyond the fascination with communication and new technologies then being talked about incessantly, and above all, beyond the predetermined grids of reading (Fluxus, in particular) into which these artists' works were being placed. *Relational Aesthetics* was the first work, to my knowledge, to provide the theoretical tools that allowed one to analyze works by individuals who would soon become irrefutably present on the international scene.

Postproduction is not a "sequel" to *Relational Aesthetics* except insofar as the two books essentially describe the same artistic scene. In terms of method, the link between them is simple: both present an analysis of today's art in relation to social changes, whether technological, economic, or sociological.

But while the former deals with a collective sensibility, *Postproduction* analyzes a set of modes of production, seeking to establish a typology of contemporary practices and to find commonalities. My first reflex was to try to avoid the artists extensively discussed in *Relational Aesthetics*. Then, after a few pages, I realized not only that they fully corresponded to this theory of production but also that I wanted to delve more deeply into these works, which the notion of relational aesthetics certainly did not exhaust. *Postproduction* therefore contains more detailed, more analytical chapters on the work of Philippe Parreno, Rirkrit Tiravanija, and Liam Gillick, emblematic of the earlier book, but also deals with the work of Thomas Hirschhorn, Mike Kelley, Michel Majerus, Sarah Morris, Pierre Joseph, and Daniel Pflumm, artists I had yet to write about. In short, the two books show the same scene from two different angles, and the more recent is more centered on form, above all, because the artists in question have impressive bodies of work behind them.

Regarding *Postproduction*, I have often heard the argument: "This is nothing new."

It's true, citation, recycling, and *détournement* were not born yester-day; what is clear is that today certain elements and principles are reemerging as themes and are suddenly at the forefront, to the point of constituting the "engine" of new artistic practices. In his journal, Eugène Delacroix developed ideas similar to those in *Relational Aesthetics*, but the remarkable thing in the nineties was that notions of interactivity, environment, and "participation" – classic art historical notions – were being rethought through and through by artists according to a radically different point of view. The critics who counter my analyses with the argument that "this is nothing new" are often the last to know that Gerald Murphy or Stuart Davis made Pop Art in the thirties – which takes nothing away from James Rosenquist or Andy Warhol. The difference resides in the articulation. The working principles of today's artists seem to me to break with the manipulation of references and citation: the works of Pierre Huyghe, Douglas Gordon, or Rirkrit Tiravanija deeply reexamine notions of creation, authorship, and originality through a problematics of the use of cultural artifacts – which, by the way, is absolutely new.

In *Postproduction*, I try to show that artists' intuitive relationship with art history is now going beyond what we call "the art of appropriation," which naturally infers an ideology of ownership, and moving toward a culture of the use of forms, a culture of constant activity of signs based on a collective ideal: sharing. The Museum like the City itself constitute a catalog of forms, postures, and images for artists – collective equipment that everyone is in a position to use, not in order to be subjected to their authority but as tools to probe the contemporary world. There is (fertile) static on the borders between consumption and production that can be perceived well beyond the borders of art. When artists find material in objects that are already in circulation on the cultural market, the work of art takes on a script-like value: "when screenplays become form," in a sense.

For me, criticism is a matter of conviction, not an exercise in flitting about and "covering" artistic current events. My theories are born of careful observation of the work in the field. I have neither the passion for objectivity of the journalist, nor the capacity for abstraction of the philosopher, who alas often seizes upon the first artists he comes across in order to illustrate his theories.

I will stick, therefore, to describing what appears around me: I do not seek to illustrate abstract ideas with a "generation" of artists but to construct ideas in their wake. I think with them. That, no doubt, is friendship, in the sense Michel Foucault intended.

INTRODUCTION

IT'S SIMPLE, PEOPLE PRODUCE WORKS, AND WE DO WHAT WE CAN WITH THEM, WE USE THEM FOR OURSELVES. (SERGE DANEY)

Postproduction is a technical term from the audiovisual vocabulary used in television, film, and video. It refers to the set of processes applied to recorded material: montage, the inclusion of other visual or audio sources, subtitling, voice-overs, and special effects. As a set of activities linked to the service industry and recycling, postproduction belongs to the tertiary sector, as opposed to the industrial or agricultural sector, i.e., the production of raw materials.

Since the early nineties, an ever increasing number of artworks have been created on the basis of preexisting works; more and more artists interpret, reproduce, re-exhibit, or use works made by others or available cultural products. This art of postproduction seems to respond to the proliferating chaos of global culture in the information age, which is characterized by an increase in the supply of works and the art world's annexation of forms ignored or disdained until now. These artists who insert their own work into that of others contribute to the eradication of the traditional distinction between production and consumption, creation and copy, readymade and original work. The material they manipulate is no longer *primary*. It is no longer a matter of elaborating a form on the basis of a raw material but working with objects that are already in circulation on the cultural market, which is to say, objects already *informed* by other objects. Notions of originality (being at the origin of) and even of creation (making something from nothing) are slowly blurred in this new cultural landscape marked by the twin figures of the DJ and the programmer, both of whom have the task of selecting cultural objects and inserting them into new contexts.

Relational Aesthetics, of which this book is a continuation, described the collective sensibility within which new forms of art have been

inscribed. Both take their point of departure in the changing mental space that has been opened for thought by the Internet, the central tool of the information age we have entered. But *Relational Aesthetics* dealt with the convivial and interactive aspect of this revolution (why artists are determined to produce models of sociality, to situate themselves within the interhuman sphere), while *Postproduction* apprehends the forms of knowledge generated by the appearance of the Net (how to find one's bearings in the cultural chaos and how to extract new modes of production from it). Indeed, it is striking that the tools most often used by artists today in order to produce these relational models are preexisting works or formal structures, as if the world of cultural products and artworks constituted an autonomous strata that could provide tools of connection between individuals; as if the establishment of new forms of sociality and a true critique of contemporary forms of life involved a different attitude in relation to artistic patrimony, through the production of new relationships to culture in general and to the artwork in particular.

A few emblematic works will allow us to outline a typology of post-production.

REPROGRAMMING EXISTING WORKS
In the video *Fresh Acconci,* 1995, Mike Kelley and Paul McCarthy recorded professional actors and models interpreting performances by Vito Acconci. In *Untitled (One Revolution Per Minute),* 1996, Rirkrit Tiravanija made an installation that incorporated pieces by Olivier Mosset, Allan McCollum, and Ken Lum; at New York's Museum of Modern Art, he annexed a construction by Philip Johnson and invited children to draw there: *Untitled (Playtime),* 1997. Pierre Huyghe projected a film by Gordon Matta-Clark, *Conical Intersect,* at the very site of its filming (*Light Conical Intersect,* 1997). In their series *Plenty of Objects of Desire,* Swetlana Heger and Plamen Dejanov exhibited artworks and design objects, which they had purchased, on minimalist

platforms. Jorge Pardo has displayed pieces by Alvar Aalto, Arne Jakobsen, and Isamu Noguchi in his installations.

INHABITING HISTORICIZED STYLES AND FORMS

Felix Gonzalez-Torres used the formal vocabularies of Minimalist art and Anti-form, recoding them almost thirty years later to suit his own political preoccupations. This same glossary of Minimalist art is diverted by Liam Gillick toward an archaeology of capitalism, by Dominique Gonzalez-Foerster toward the sphere of the intimate, by Pardo toward a problematics of use, and by Daniel Pflumm toward a questioning of the notion of production. Sarah Morris employs the modernist grid in her painting in order to describe the abstraction of economic flux. In 1993, Maurizio Cattelan exhibited *Untitled,* a canvas that reproduced Zorro's famous Z in the lacerated style of Lucio Fontana. Xavier Veilhan exhibited *La Forêt,* 1998, whose brown felt evoked Joseph Beuys and Robert Morris, in a structure that recalled Jesús Soto's *Penetrable* sculptures. Angela Bulloch, Tobias Rehberger, Carsten Nicolai, Sylvie Fleury, John Miller, and Sydney Stucki, to name only a few, have adapted minimalist, Pop, or conceptual structures and forms to their personal problematics, going as far as duplicating entire sequences from existing works of art.

MAKING USE OF IMAGES

At the Aperto at the 1993 Venice Biennale, Bulloch exhibited a video of *Solaris*, the science fiction film by Andrei Tarkovsky, replacing its sound track with her own dialogue. *24 Hour Psycho,* 1997, a work by Douglas Gordon, consisted of a projection of Alfred Hitchcock's film *Psycho* slowed down to run for twenty-four hours. Kendell Geers has isolated sequences of well-known films (Harvey Keitel grimacing in *Bad Lieutenant,* a scene from *The Exorcist*) and looped them in his video installations; for *TV Shoot,* 1998-99, he took scenes of shootouts from the contemporary cinematic repertory and projected them onto two screens that faced each other.

USING SOCIETY AS A CATALOG OF FORMS

When Matthieu Laurette is reimbursed for products he has consumed by systematically using promotional coupons ("Satisfaction guaranteed or your money back"), he operates within the cracks of the promotional system. When he produces the pilot for a game show on the principle of exchange (*El Gran trueque,* 2000) or establishes an offshore bank with the aid of funds from donation boxes placed at the entrance of art centers (*Laurette Bank Unlimited,* 1999), he plays with economic forms as if they were the lines and colors of a painting. Jens Haaning transforms art centers into import-export stores and clandestine workshops; Daniel Pflumm appropriates the logos of multinationals and endows them with their own aesthetic life. Heger and Dejanov take every job they can in order to acquire "objects of desire" and rent their work force to BMW for an entire year. Michel Majerus, who integrates the technique of sampling into his pictorial practice, exploits the rich visual stratum of promotional packaging.

INVESTING IN FASHION AND MEDIA

The works of Vanessa Beecroft come from an intersection between performance and the protocol of fashion photography; they reference the form of performance without being reduced to it. Sylvie Fleury indexes her production to the glamorous world of trends offered by women's magazines, stating that when she isn't sure what colors to use in her work, she uses the new colors by Chanel. John Miller has produced a series of paintings and installations based on the aesthetic of television game shows. Wang Du selects images published in the press and duplicates them in three dimensions as painted wood sculptures.

All these artistic practices, although formally heterogeneous, have in common the recourse to *already produced* forms. They testify to a willingness to inscribe the work of art within a network of signs and significations, instead of considering it an autonomous or original form.

It is no longer a matter of starting with a "blank slate" or creating meaning on the basis of virgin material but of finding a means of insertion into the innumerable flows of production. "Things and thoughts," Gilles Deleuze writes, "advance or grow out from the middle, and that's where you have to get to work, that's where everything unfolds."[01] The artistic question is no longer: "what can we make that is new?" but "how can we make do with what we have?" In other words, how can we produce singularity and meaning from this chaotic mass of objects, names, and references that constitutes our daily life? Artists today program forms more than they compose them: rather than transfigure a raw element (blank canvas, clay, etc.), they remix available forms and make use of *data*. In a universe of products for sale, preexisting forms, signals already emitted, buildings already constructed, paths marked out by their predecessors, artists no longer consider the artistic field (and here one could add television, cinema, or literature) a museum containing works that must be cited or "surpassed," as the modernist ideology of originality would have it, but so many storehouses filled with tools that should be used, stockpiles of data to manipulate and present. When Tiravanija offers us the experience of a structure in which he prepares food, he is not doing a performance: he is using the performance-form. His goal is not to question the limits of art: he uses forms that served to interrogate these limits in the sixties, in order to produce completely different results. Tiravanija often cites Ludwig Wittgenstein's phrase: "Don't look for the meaning, look for the use."

The prefix "post" does not signal any negation or surpassing; it refers to a zone of activity. The processes in question here do not consist of producing images of images, which would be a fairly mannered posture, or of lamenting the fact that everything has "already been

01 GILLES DELEUZE, *NEGOTIATIONS*, TRANS. MARTIN JOUGHIN (NEW YORK: COLUMBIA UNIVERSITY PRESS, 1995), P. 161.

done," but of inventing protocols of use for all existing modes of representation and all formal structures. It is a matter of seizing all the codes of the culture, all the forms of everyday life, the works of the global patrimony, and making them function. To learn how to use forms, as the artists in question invite us to do, is above all to know how to make them one's own, to inhabit them.

The activities of DJs, Web surfers, and postproduction artists imply a similar configuration of knowledge, which is characterized by the invention of paths through culture. All three are "semionauts" who produce original pathways through signs. Every work is issued from a script that the artist projects onto culture, considered the framework of a narrative that in turn projects new possible scripts, endlessly. The DJ activates the history of music by copying and pasting together loops of sound, placing recorded products in relation with each other. Artists actively inhabit cultural and social forms. The Internet user may create his or her own site or homepage and constantly reshuffle the information obtained, inventing paths that can be bookmarked and reproduced at will. When we start a search engine in pursuit of a name or a subject, a mass of information issued from a labyrinth of databanks is inscribed on the screen. The "semionaut" imagines the links, the likely relations between disparate sites. A sampler, a machine that reprocesses musical products, also implies constant activity; to listen to records becomes work in itself, which diminishes the dividing line between reception and practice, producing new cartographies of knowledge. This recycling of sounds, images, and forms implies incessant navigation within the meanderings of cultural history, navigation which itself becomes the subject of artistic practice. Isn't art, as Duchamp once said, "a game among all men of all eras?" Postproduction is the contemporary form of this game.

When musicians use a sample, they know that their own contribution may in turn be taken as the base material of a new composition.

They consider it normal that the sonorous treatment applied to the borrowed loop could in turn generate other interpretations, and so on and so forth. With music derived from sampling, the *sample* no longer represents anything more than a salient point in a shifting cartography. It is caught in a chain, and its meaning depends in part on its position in this chain. In an online chat room, a message takes on value the moment it is repeated and commented on by someone else. Likewise, the contemporary work of art does not position itself as the termination point of the "creative process" (a "finished product" to be contemplated) but as a site of navigation, a portal, a generator of activities. We tinker with production, we surf on a network of signs, we insert our forms on existing lines.

What unites the various configurations of the artistic use of the world gathered under the term postproduction is the scrambling of boundaries between consumption and production. "Even if it is illusory and utopian," Dominique Gonzalez-Foerster explains, "what matters is introducing a sort of equality, assuming the same capacities, the possibility of an equal relationship, between me – at the origins of an arrangement, a system – and others, allowing them to organize their own story in response to what they have just seen, with their own references."[02]

In this new form of culture, which one might call a culture of use or a culture of activity, the artwork functions as the temporary terminal of a network of interconnected elements, like a narrative that extends and reinterprets preceding narratives. Each exhibition encloses within it the script of another; each work may be inserted into different

02 DOMINIQUE GONZALEZ-FOERSTER, "DOMINIQUE GONZALEZ-FOERSTER, PIERRE HUYGHE AND PHILIPPE PARRENO IN CONVERSATION WITH JEAN-CHRISTOPHE ROYOUX" IN *DOMINIQUE GONZALEZ-FOERSTER, PIERRE HUYGHE, PHILIPPE PARRENO*, EXH. CAT. (PARIS: MUSÉE D'ART MODERNE DE LA VILLE DE PARIS, 1998), P. 82.

programs and used for multiple scenarios. The artwork is no longer an end point but a simple moment in an infinite chain of contributions.

This culture of use implies a profound transformation of the status of the work of art: going beyond its traditional role as a receptacle of the artist's vision, it now functions as an active agent, a musical score, an unfolding scenario, a framework that possesses autonomy and materiality to varying degrees, its form able to oscillate from a simple idea to sculpture or canvas. In generating behaviors and potential reuses, art challenges passive culture, composed of merchandise and consumers. It makes the forms and cultural objects of our daily lives *function*. What if artistic creation today could be compared to a collective sport, far from the classical mythology of the solitary effort? "It is the viewers who make the paintings," Duchamp once said, an incomprehensible remark unless we connect it to his keen sense of an emerging culture of use, in which meaning is born of collaboration and negotiation between the artist and the one who comes to view the work. Why wouldn't the meaning of a work have as much to do with the use one makes of it as with the artist's intentions for it?

THE USE OF OBJECTS

The difference between artists who produce works based on objects already produced and those who operate ex nihilo is one that Karl Marx observes in *German Ideology:* there is a difference, he says, between natural tools of production (e.g., working the earth) and tools of production created by civilization. In the first case, Marx argues, individuals are subordinate to nature. In the second, they are dealing with a "product of labor," that is, *capital,* a mixture of accumulated labor and tools of production. These are only held together by exchange, an interhuman transaction embodied by a third term, money. The art of the twentieth century developed according to a similar schema: the industrial revolution made its effects felt, but with some delay. When Marcel Duchamp exhibited a bottle rack in 1914 and used a mass-produced object as a "tool of production," he brought the capitalist process of production (working on the basis of *accumulated labor*) into the sphere of art, while at the same time indexing the role of the artist to the world of exchange: he suddenly found kinship with the merchant, content to move products from one place to another. Duchamp started from the principle that consumption was also a mode of production, as did Marx, who writes in his introduction to *Critique of Political Economy* that "consumption is simultaneously also production, just as in nature the production of a plant involves the consumption of elemental forces and chemical materials." Marx adds that "man produces his own body, e.g., through feeding, one form of consumption." A product only becomes a real product in consumption; as Marx goes on to say, "a dress becomes really a dress only by being worn, a house which is uninhabited is indeed not really a house."[01] Because consumption creates the need for new production, consumption is both its motor and motive. This is the primary virtue of the readymade: establishing an equivalence between choosing and fabricating, consuming and producing – which is

01 KARL MARX, *A CONTRIBUTION TO THE CRITIQUE OF POLITICAL ECONOMY,* TRANS. S.W. RYAZANSKAYA, ED. MAURICE DOBB (NEW YORK: INTERNATIONAL PUBLISHERS, 1970), PP. 195-96.

difficult to accept in a world governed by the Christian ideology of effort ("working by the sweat of your brow") or that of the worker-hero (Stakhanovism).

In *The Practice of Everyday Life,* the astonishing structuralist Michel de Certeau examines the hidden movements beneath the surface of the Production-Consumption pair, showing that far from being purely passive, the consumer engages in a set of processes comparable to an almost clandestine, "silent" production.[02] To use an object is necessarily to interpret it. To use a product is to betray its concept. To read, to view, to envision a work is to know how to divert it: use is an act of micropirating that constitutes postproduction. We never read a book the way its author would like us to. By using television, books, or records, the user of culture deploys a rhetoric of practices and "ruses" that has to do with enunciation and therefore with language whose figures and codes may be catalogued.

Starting with the language imposed upon us (the *system* of production), we construct our own sentences (*acts* of everyday life), thereby reappropriating for ourselves, through these clandestine micro-bricolages, the last word in the productive chain. Production thus becomes a lexicon of a practice, which is to say, the intermediary material from which new utterances can be articulated, instead of representing the end result of anything. What matters is what we make of the elements placed at our disposal. We are tenants of culture: society is a text whose law is production, a law that so-called passive users divert from within, through the practices of postproduction. Each artwork, de Certeau suggests, is inhabitable in the manner of a rented apartment. By listening to music or reading a book, we produce new material, we become producers. And each day we benefit

02 SEE MICHEL DE CERTEAU, *THE PRACTICE OF EVERYDAY LIFE,* TRANS. STEVEN RENDELL (BERKELEY: UNIVERSITY OF CALIFORNIA PRESS, 1984).

from more ways in which to organize this production: remote controls, VCRs, computers, MP3s, tools that allow us to select, reconstruct, and edit. Postproduction artists are agents of this evolution, the specialized workers of cultural reappropriation.

THE USE OF THE PRODUCT FROM MARCEL DUCHAMP TO JEFF KOONS

Appropriation is indeed the first stage of postproduction: the issue is no longer to fabricate an object, but to choose one among those that exist and to use or modify these according to a specific intention. Marcel Broodthaers said that "since Duchamp, the artist is the author of a definition" which is substituted for that of the objects he or she has chosen. The history of appropriation (which remains to be written) is nevertheless not the topic of this chapter; only a few of its figures, useful to the comprehension of the most recent art, will be mentioned here. If the process of appropriation has its roots in history, its narrative here will begin with the readymade, which represents its first conceptualized manifestation, considered in relation to the history of art. When Duchamp exhibits a manufactured object (a bottle rack, a urinal, a snow shovel) as a work of the mind, he shifts the problematic of the "creative process," emphasizing the artist's gaze brought to bear on an object instead of manual skill. He asserts that the act of choosing is enough to establish the artistic process, just as the act of fabricating, painting, or sculpting does: to give a new idea to an object is already production. Duchamp thereby completes the definition of the term *creation:* to create is to insert an object into a new scenario, to consider it a character in a narrative.

The main difference between European New Realism and American Pop resides in the nature of the gaze brought to bear on consumption. Arman, César, and Daniel Spoerri seem fascinated by the act of consumption itself, relics of which they exhibit. For them, consumption is truly an abstract phenomenon, a myth whose invisible subject seems

irreducible to any representation. Conversely, Andy Warhol, Claes Oldenburg, and James Rosenquist bring their gaze to bear on the purchase, on the visual impetus that propels an individual to acquire a product: their goal is less to document a sociological phenomenon than to exploit new iconographic material. They investigate, above all, advertising and its mechanics of visual frontality, while the Europeans, further removed, explore the world of consumption through the filter of the great organic metaphor and favor the use value of things over their exchange value. The New Realists are more interested in the impersonal and collective use of forms than in the individual use of these forms, as the works of "poster artists" Raymond Hains and Jacques de la Villeglé admirably show: the city itself is the anonymous and multiple author of the images they collect and exhibit as artworks. No one consumes, things are consumed. Spoerri demonstrates the poetry of table scraps, Arman that of trash cans and supplies; César exhibits a crushed, unusable automobile, at the end of its destiny as a vehicle. Apart from Martial Raysse, the most "American" of the Europeans, the concern is still to show the end result of the process of consumption, which others have practiced. The New Realists have thus invented a sort of postproduction squared: their subject is certainly consumption, but a represented consumption, carried out in an abstract and generally anonymous way, whereas Pop explores the visual conditioning (advertising, packaging) that accompanies mass consumption. By salvaging already used objects, products that have come to the end of their functional life, the New Realists can be seen as the first landscape painters of consumption, the authors of the first still lifes of industrial society.

With Pop art, the notion of consumption constituted an abstract theme linked to mass production. It took on concrete value in the early eighties, when it was attached to individual desires. The artists who lay claim to Simulationism considered the work of art to be an "absolute commodity" and creation a mere substitute for the act of consuming.

I buy, therefore I am, as Barbara Kruger wrote. The object was shown from the angle of the compulsion to buy, from the angle of desire, midway between the inaccessible and the available. Such is the task of marketing, which is the true subject of Simulationist works. Haim Steinbach thus arranged mass-produced objects or antiques on minimal and monochromatic shelves. Sherrie Levine exhibited exact copies of works by Miró, Walker Evans and Degas. Jeff Koons displayed advertisements, salvaged kitsch icons, and floated basketballs weightlessly in immaculate containers. Ashley Bickerton produced a self-portrait composed of the logos of products he used in daily life.

Among the Simulationists, the work resulted from a contract stipulating the equal importance of the consumer and the artist/purveyor. Koons used objects as convectors of desire: "In the system I was brought up in – the Western, capitalist system – one receives objects as rewards for labour and achievement. ... And once these objects have been accumulated, they work as support mechanisms for the individual: to define the personality of the self, to fulfill desires and express them."[03] Koons, Levine, and Steinbach present themselves as veritable intermediaries, *brokers of desire* whose works represent simple simulacra, images born of a market study more than of some sort of "inner need," a value considered outmoded. The ordinary object of consumption is doubled by another object, this one purely virtual, designating an inaccessible state, a lack (e.g., Jeff Koons). The artist consumes the world in place of the viewer, and for him. He arranges objects in glass cases that neutralize the notion of use in favor of a sort of interrupted exchange, in which the moment of *presentation* is made sacred. Through the generic structure of the shelf, Haim Steinbach emphasizes its predominance in our mental

03 JEFF KOONS, FROM AN INTERVIEW WITH GIANCARLO POLITI IN *FLASH ART,* NO. 132, FEBRUARY-MARCH 1987, QUOTED BY ANN GOLDSTEIN IN *A FOREST OF SIGNS: ART IN THE CRISIS OF REPRESENTATION,* ED. CATHERINE GUDIS (LA: MUSEUM OF CONTEMPORARY ART AND CAMBRIDGE, MA: THE MIT PRESS, 1989), P. 39.

universe: we only look at what is well-presented; we only desire what is desired by others. The objects he displays on his wood and Formica shelves "are bought or taken, placed, matched, and compared. They are moveable, arranged in a particular way, and when they get packed they are taken apart again, and they are as permanent as objects are when you buy them in a store." The subject of his work is what happens in any exchange.

THE FLEA MARKET: THE DOMINANT ART FORM OF THE NINETIES

As Liam Gillick explains, "in the eighties, a large part of artistic production seemed to mean that artists went shopping in the right shops. Now, it seems as though new artists have gone shopping, too, but in unsuitable shops, in all sorts of shops."[04] The passage from the eighties to the nineties might be represented by the juxtaposition of two photographs: one of a shop window, another of a flea market or airport shopping mall. From Jeff Koons to Rirkrit Tiravanija, from Haim Steinbach to Jason Rhoades, one formal system has been substituted for another: since the early nineties, the dominant visual model is closer to the open-air market, the bazaar, the souk, a temporary and nomadic gathering of precarious materials and products of various provenances. Recycling (a method) and chaotic arrangement (an aesthetic) have supplanted shopping, store windows, and shelving in the role of formal matrices.

Why has the market become the omnipresent referent for contemporary artistic practices? First, it represents a collective form, a disordered, proliferating and endlessly renewed conglomeration that does not depend on the command of a single author: a market is not designed, it is a unitary structure composed of multiple individual signs. Secondly, this form (in the case of the flea market) is the locus

04 SEE LIAM GILLICK IN *NO MAN'S TIME*, EXH. CAT. (NICE: CNAC VILLA ARSON, 1991).

of a reorganization of past production. Finally, it embodies and makes material the flows and relationships that have tended toward disembodiment with the appearance of online shopping.

A flea market, then, is a place where products of multiple provenances converge, waiting for new uses. An old sewing machine can become a kitchen table, an advertising poster from the seventies can serve to decorate a living room. Here, past production is recycled and switches direction. In an involuntary homage to Marcel Duchamp, an object is given a new idea. An object once used in conformance with the concept for which it was produced now finds new potential uses in the stalls of the flea market.

Dan Cameron used Claude Lévi-Strauss's opposition between "the raw and the cooked" as the title for an exhibition he curated: it included artists who transformed materials and made them unrecognizable (the cooked), and artists who preserved the singular aspect of these materials (the raw). The market-form is the quintessential place for this rawness: an installation by Jason Rhoades, for example, is presented as a unitary composition made of objects, each of which retains its expressive autonomy, in the manner of paintings by Arcimboldo. Formally, Rhoades's work is quite similar to Rirkrit Tiravanija's. *Untitled (Peace Sells),* which Tiravanija made in 1999, is an exuberant display of disparate elements that clearly testifies to a resistance to unifying the diverse, perceptible in all his work. But Tiravanija organizes the multiple elements that make up his installations so as to underscore their use value, while Rhoades presents objects that seem endowed with an autonomous logic, quasi-indifferent to the human. We can see one or more guiding lines, structures imbricated within one another, but the atoms brought together by the artist do not blend completely into an organic whole. Each object seems to resist a formal unity, forming subsets that resist projection into a vaster whole and that at times are transplanted from one

structure to another. The domain of forms that Rhoades is referencing, then, evokes the heterogeneity of stalls in a market and the meandering that implies: "… it's about relationships to people, like me to my dad, or tomatoes to squash, beans to weeds, and weeds to corn, corn to the ground and the ground to the extension cords."[05] As explicit references to the open markets of the artist's early days in California, his installations conjure an alarming image of a world with no possible center, collapsing on all sides beneath the weight of production and the practical impossibility of recycling. In visiting them, one senses that the task of art is no longer to propose an artificial synthesis of heterogeneous elements but to generate "critical mass" through which the familial structure of the nearby market metamorphoses into a vast warehouse for merchandise sold online, a monstrous city of detritus. His works are composed of materials and tools, but on an outsize scale: "piles of pipes, piles of clamps, piles of paper, piles of fabric, all these industrial quantities of things …"[06] Rhoades adapts the provincial junk fair to the dimensions of Los Angeles, through the experience of driving a car. When asked to explain the evolution of his piece *Perfect World,* he replies: "The really big change in the new work is the car." Driving in his Chevrolet Caprice, he was "in and out of [his] head, and in and out of reality," while the acquisition of a Ferrari modified his relationship to the city and to his work: "Driving between the studio and between various places, I am physically driving, it's a great energy, but it's not this daydream wandering head thing like before."[07] The space of the work is urban space, traversed at a certain speed: the objects that endure are therefore necessarily enormous or reduced to the size of the car's interior, which takes on the role of an optical tool allowing one to select forms.

05 JASON RHOADES, *PERFECT WORLD*, EXH. CAT. (COLOGNE: OKTAGON/DEICHTORHALLEN HAMBURG, 2000), P. 15.

06 IBID., P. 22.

07 IBID., P. 53.

Thomas Hirschhorn's work relies not on spaces of exchange but places where the individual loses contact with the social and becomes embedded in an abstract background: an international airport, a department store's windows, a company's headquarters, and so on. In his installations, sheets of aluminum foil or plastic are wrapped around vague everyday forms which, made uniform in this way, are projected into monstrous, proliferating, tentacle-like form-networks. Yet this work relates to the market-form insofar as it introduces elements of resistance and information (political tracts, articles cut out of newspapers, television sets, media images) into places typical of the globalized economy. Visitors who move through Hirschhorn's environments uneasily traverse an abstract, woolly, and chaotic organism. They can identify the objects they encounter – newspapers, vehicles, ordinary objects – but in the form of sticky specters, as if a computer virus had ravaged the spectacle of the world and replaced it with a genetically modified substitute. These ordinary products are presented in a larval state, like so many interconnected matrices in a capillary network leading nowhere, which in itself is a commentary on the economy. A similar malaise surrounds the installations of George Adeagbo, who presents an image of the African economy of recycling through a maze of old record covers, scrap items, and newspaper clippings, for which personal notes, analogous to a private journal, act as captions, an irruption of human consciousness into the misery of display.

At the end of the eighteenth century, the term "market" moved away from its physical referent and began to designate the abstract process of buying and selling. In the bazaar, economist Michel Henochsberg explains, "transaction goes beyond the dry and reductive simplification in which modernity rigs it," assuming its original status as a negotiation between two people. Commerce is above all a form of human relations, indeed, a pretext destined to produce a relationship. Any transaction may be defined as "a successful encounter of histories,

affinities, wishes, constraints, habits, threats, skins, tensions."[08]

Art tends to give shape and weight to the most invisible processes.
When entire sections of our existence spiral into abstraction as a
result of economic globalization, when the basic functions of our daily
lives are slowly transformed into products of consumption (including
human relations, which are becoming a full-fledged industrial concern),
it seems highly logical that artists might seek to *rematerialize* these
functions and processes, to give shape to what is disappearing before
our eyes. Not as objects, which would be to fall into the trap of reifica-
tion, but as mediums of experience: by striving to shatter the logic
of the spectacle, art restores the world to us as an experience to
be lived. Since the economic system gradually deprives us of this
experience, modes of representation must be invented for a reality
that is becoming more abstract each day. A series of paintings by
Sarah Morris that depicts the facades of multinational corporate head-
quarters in the style of geometric abstraction gives a physical place
to brands that appear to be purely immaterial. By the same logic,
Miltos Manetas's paintings take as subjects the Internet and the
power of computers, but use the features of physical objects situated
in a domestic interior to allow us access to them. The current suc-
cess of the market as a formal matrix among contemporary artists
has to do with a desire to make commercial relations concrete once
again, relations that the postmodern economy tends to make imma-
terial. And yet this immateriality itself is a fiction, Henochsberg sug-
gests, insofar as what seems most abstract to us – high prices for
raw materials or energy, say – are in reality the object of arbitrary
negotiations.

The work of art may thus consist of a formal arrangement that gen-

08 MICHEL HENOCHSBERG, *NOUS NOUS SENTIONS COMME UNE SALE ESPÈCE: SUR LE COMMERCE ET
L'ÉCONOMIE* (PARIS: DENOËL, 1999), P. 239.

erates relationships between people, or be born of a social process; I have described this phenomenon as "relational aesthetics," whose main feature is to consider interhuman exchange an aesthetic object in and of itself.

With *Everything NT$20 (Chaos minimal),* 2000, Surasi Kusolwong heaped thousands of brightly-colored objects onto rectangular shelves with monochromatic surfaces. The objects – T-shirts, plastic gadgets, baskets, toys, cooking utensils, and so on – were produced in his country of origin, Thailand. The colorful piles gradually diminished, like Felix Gonzalez-Torres's "stacks," as visitors of the exhibition carried away the objects for a small sum; the money was placed in large transparent smoked-glass urns that explicitly evoked Robert Morris's sculptures from the sixties. What Kusolwong's arrangement clearly depicted was the world of transaction: the dissemination of multicolored products in the exhibition space and the gradual filling of containers by coins and bills provided a concrete image of commercial exchange. When Jens Haaning organized a store in Fribourg featuring products imported from France at prices clearly lower than those charged in Switzerland, he questioned the paradoxes of a falsely "global" economy and assigned the artist the role of smuggler.

THE USE OF FORMS

THE EIGHTIES AND THE BIRTH OF DJ CULTURE: TOWARD A FORMAL COLLECTIVISM

Throughout the eighties, the democratization of computers and the appearance of sampling allowed for the emergence of a new cultural configuration, whose emblematic figures are the programmer and the DJ. The remixer has become more important than the instrumentalist, the rave more exciting than the concert. The supremacy of cultures of appropriation and the reprocessing of forms calls for an ethics: to paraphrase Philippe Thomas, artworks belong to everyone. Contemporary art tends to abolish the ownership of forms, or in any case to shake up the old jurisprudence. Are we heading toward a culture that would do away with copyright in favor of a policy allowing free access to works, a sort of blueprint for a communism of forms?

In 1956, Guy Debord published "Methods of Detournement:" "The literary and artistic heritage of humanity should be used for partisan propaganda purposes. ... Any elements, no matter where they are taken from, can serve in making new combinations. ... Anything can be used. It goes without saying that one is not limited to correcting a work or to integrating diverse fragments of out-of-date works into a new one; one can also alter the meaning of these fragments in any appropriate way, leaving the imbeciles to their slavish preservation of 'citations.'"[01]

With the Lettrist International, then the Situationist International that followed in 1958, a new notion appeared: artistic *détournement*

01 GUY DEBORD, "METHODS OF DETOURNEMENT" IN *SITUATIONIST INTERNATIONAL ANTHOLOGY*, ED. AND TRANS. KEN KNABB (BERKELEY: BUREAU OF PUBLIC SECRETS, 1981), P. 9.

(diversion),[02] which might be described as a political use of Duchamp's reciprocal readymade (his example of this was "using a Rembrandt as an ironing board"). This reuse of preexisting artistic elements in a new whole was one of the tools that contributed to surpassing artistic activity based on the idea of "separate" art executed by specialized producers. The Situationist International applauded the *détournement* of existing works in the optic of impassioning everyday life, favoring the construction of lived situations over the fabrication of works that confirmed the division between actors and spectators of existence. For Guy Debord, Asger Jorn, and Gil Wolman, the primary artisans of the theory of *détournement,* cities, buildings, and works were to be considered parts of a backdrop or festive and playful tools. The Situationists extolled *la dérive* (or drift), a technique of navigating through various urban settings as if they were film sets. These situations, which had to be constructed, were experienced, ephemeral, and immaterial works, an art of the passing of time resistant to any fixed limitations. Their task was to eradicate, with tools borrowed from the modern lexicon, the mediocrity of an alienated everyday life in which the artwork served as a screen, or a consolation, representing nothing other than the materialization of a lack. As Anselm Jappe writes, "the Situationist criticism of the work of art is curiously reminiscent of the psychoanalytical account, according to which such productions are the sublimation of unfulfilled wishes."[03] The Situationist *détournement* was not one option in a catalog of artistic techniques, but the sole possible mode of using art, which represented nothing more than an obstacle to the completion of the avant-garde project. As Asger Jorn asserts in his essay "Peinture

02 IN *SOCIETY OF THE SPECTACLE,* DEBORD'S TRANSLATOR, DONALD NICHOLSON-SMITH, LEAVES DÉTOURNEMENT IN FRENCH, OCCASIONALLY INTERCHANGING IT WITH "DIVERSION." DÉTOURNEMENT CAN ALSO MEAN HIJACKING, EMBEZZLEMENT, AND CORRUPTION – TRANS.

03 ANSELM JAPPE, *GUY DEBORD,* TRANS. DONALD NICHOLSON-SMITH (BERKELEY: UNIVERSITY OF CALIFORNIA PRESS, 1999), P. 70.

détournée" (Diverted Painting, 1959), all the works of the past must be "reinvested" or disappear. There cannot, therefore, be a "Situationist art," but only a Situationist use of art, which involves its depreciation. The "Report on the Construction of Situations...," which Guy Debord published in 1957, encouraged the use of existing cultural forms by contesting any value proper to them. *Détournement,* as he would specify later in *Society of the Spectacle,* is "not a negation of style, but the style of negation."[04] Jorn defined it as "a game" made possible by "devalorization."

While the *détournement* of preexisting artworks is a currently employed tool, artists use it not to "devalorize" the work of art but to utilize it. In the same way that Surrealists used Dadaist techniques to a constructive end, art today manipulates Situationist methods without targeting the complete abolition of art. We should note that an artist such as Raymond Hains, a splendid practitioner of *la dérive* and instigator of an infinite network of interconnected signs, emerges as a precursor here. Artists today practice postproduction as a neutral, zero-sum process, whereas the Situationists aimed to corrupt the value of the diverted work, i.e., to attack cultural capital itself. As Michel de Certeau has suggested, production is a form of capital by which consumers carry out a set of procedures that makes them renters of culture.

While recent musical trends have made *détournement* banal, artworks are no longer perceived as obstacles but as building materials. Any DJ today bases his or her work on principles inherited from the history of the artistic avant-garde: *détournement,* reciprocal or assisted readymades, the dematerialization of activities, and so on.

According to Japanese musician Ken Ishii, "the history of techno music

04 GUY DEBORD, *SOCIETY OF THE SPECTACLE,* TRANS. DONALD NICHOLSON-SMITH (NEW YORK: ZONE BOOKS, 1994), P. 144.

resembles that of the Internet. Now everyone can compose musics endlessly, musics that are broken down more and more into different genres based on everyone's personality. The entire world will be filled with diverse, personal musics, which will inspire even more. I'm sure that new musics will be born from now on, unceasingly."[05]

During a set, a DJ plays records, i.e., products. The DJ's work consists both of proposing a personal orbit through the musical universe (a playlist) and of connecting these elements in a certain order, paying attention to their sequence as well as to the construction of an atmosphere (working directly on the crowd of dancers or reacting to their movements). He or she may also act physically on the object being used, by scratching or using a whole range of actions (filters, adjusting the mixing levels, adding sounds, and so on). A DJ's set is not unlike an exhibition of objects that Duchamp would have described as "assisted readymades:" more or less modified products whose sequence produces a specific duration. One can recognize a DJ's style in the ability to inhabit an open network (the history of sound) and in the logic that organizes the links between the samples he or she plays. Deejaying implies a culture of the use of forms, which connects rap, techno, and all their subsequent by-products.

Clive Campbell, alias DJ Kool Herc, already practiced a primitive form of sampling in the seventies, the "breakbeat," which involved isolating a musical phrase and looping it by going back and forth between two turntables playing copies of the same vinyl record.

As DJ Mark the 45 King says: "I'm not stealing all their music, I'm using your drum track, I'm using this little 'bip' from him, I'm using your bassline that you don't even like no fucking more."[06]

05 GUILLAUME BARA, *LA TECHNO* (PARIS: LIBRIO, 1999), P. 60.

DEEJAYING AND CONTEMPORARY ART: SIMILAR CONFIGURATIONS

When the *crossfader* of the mixing board is set in the middle, two samples are played simultaneously: Pierre Huyghe presents an interview with John Giorno and a film by Andy Warhol side by side.

The *pitch control* allows one to control the speed of the record: *24 Hour Psycho* by Douglas Gordon.

Toasting, rapping, MCing: Angela Bulloch dubs *Solaris* by Andrei Tarkovsky.

Cutting: Alex Bag records passages from a television program; Candice Breitz isolates short fragments of images and repeats them.

Playlists: For their collaborative project *Cinéma Liberté Bar Lounge,* 1996, Douglas Gordon offered a selection of films censored upon their release, while Rirkrit Tiravanija constructed a festive setting for the programming.

In our daily lives, the gap that separates production and consumption narrows each day. We can produce a musical work without being able to play a single note of music by making use of existing records. More generally, the consumer customizes and adapts the products that he or she buys to his or her personality or needs. Using a remote control is also production, the timid production of alienated leisure time: with your finger on the button, you construct a program. Soon, Do-It-Yourself will reach every layer of cultural production: the musicians of Coldcut accompany their album *Let us play* (1997) with a CD-ROM that allows you to remix the record yourself.

The *ecstatic consumer* of the eighties is fading out in favor of an intelligent and potentially subversive consumer: the user of forms.

06 S.H. FERNANDO JR., *THE NEW BEATS: EXPLORING THE MUSIC, CULTURE AND ATTITUDES OF HIP-HOP* (NEW YORK: ANCHOR BOOKS/DOUBLEDAY, 1994), P. 246. [THE FRENCH EDITION WAS PUBLISHED IN PARIS BY KARGO IN 2000.]

DJ culture denies the binary opposition between the proposal of the *transmitter* and the participation of the *receiver* at the heart of many debates on modern art. The work of the DJ consists in conceiving linkages through which the works flow into each other, representing at once a product, a tool, and a medium. The producer is only a *transmitter* for the following producer, and each artist from now on evolves in a network of contiguous forms that dovetail endlessly. The product may serve to make work, the work may once again become an object: a rotation is established, determined by the use that one makes of forms.

As Angela Bulloch states, "when Donald Judd made furniture, he said something like: 'a chair is not a sculpture, because you can't see it when you're sitting on it.' So its functional value prevents it from being an art object, but I don't think that makes any sense."

The quality of a work depends on the trajectory it describes in the cultural landscape. It constructs a linkage between forms, signs, and images.

In the installation *Test Room Containing Multiple Stimuli Known to Elicit Curiosity and Manipulatory Responses,* 1999, Mike Kelley engages in a veritable archaeology of modernist culture, organizing a confluence of iconographic sources that are heterogeneous to say the least: Noguchi's sets for ballets by Martha Graham, scientific experiments on children's reaction to TV violence, Harlow's experiments on the love life of monkeys, performance, video, and Minimalist sculpture. Another of his works, *Framed & Frame (Miniature Reproduction "Chinatown Wishing Well" built by Mike Kelley after "Miniature Reproduction Seven Star Cavern" built by Prof. H. K. Lu),* 1999, reconstructs and deconstructs the Chinatown Wishing Well in Los Angeles in two distinct installations, as if the popular votive sculpture and its touristic setting (a low wall surrounded by wire fencing) belonged

to "different categories."[07] Here again, the ensemble blends hetero-
geneous aesthetic universes: Chinese-American kitsch, Buddhist and
Christian statuary, graffiti, tourist infrastructures, sculptures by Max
Ernst, and abstract art. With *Framed & Frame,* Kelley strove "to render
shapes generally used to signify the formless," to depict visual con-
fusion, the amorphous state of the image, "the unfixed qualities of
cultures in collision."[08] These clashes, which represent the everyday
experience of city dwellers in the twenty-first century, also represent
the subject of Kelley's work: global culture's chaotic melting pot, into
which high and low culture, East and West, art and nonart, and an
infinite number of iconic registers and modes of production are poured.
The separation in two of the Chinatown Wishing Well, aside from
obliging one to think of its frame as a "distinct visual entity,"[09] more
generally indicates Kelley's major theme: *détourage,*[10] which is to say,
the way our culture operates by transplanting, grafting, and decon-
textualizing things. The frame is at once a marker – an index that
points to what should be looked at – and a boundary that prevents
the framed object from lapsing into instability and abstraction, i.e.,
the vertigo of *that which is not referenced,* wild, "untamed" culture.
Meanings are first produced by a social framework. As the title of
an essay by Kelley puts it, "meaning is confused spatiality, framed."

High culture relies on an ideology of framing and the pedestal, on the
exact delineation of the objects it promotes, enshrined in categories
and regulated by codes of presentation. Low culture, conversely,
develops in the exaltation of outer limits, bad taste, and transgression

07 MIKE KELLEY, "THE MEANING IS CONFUSED SPATIALITY, FRAMED" IN *MIKE KELLEY,* EXH. CAT. (GRENOBLE:
LE MAGASIN, 1999), P. 62.

08 IBID., P. 64.

09 IBID.

10 DÉTOURAGE IS THE PROCESS OF BLOCKING OUT THE BACKGROUND (OF A PROFILE, ETC.) IN PHOTO-
GRAPHY OR ENGRAVING – TRANS.

– which does not mean that it does not produce its own *framing system*. Kelley's work proceeds by short-circuiting these two focal points, the tight framing of museum culture mixed with the blur that surrounds pop culture. *Détourage,* the seminal gesture in Kelley's work, appears to be the major figure of contemporary culture as well: the embedding of popular iconography in the system of high art, the decontextualization of the mass-produced object, the displacement of works from the canon toward commonplace contexts. The art of the twentieth century is an art of *montage* (the succession of images) and *détourage* (the superimposition of images).

Kelley's "Garbage Drawings," 1988, for example, have their origin in the depiction of garbage in comic strips. One might compare them to Bertrand Lavier's "Walt Disney Productions" series, 1985, in which the paintings and sculptures that form the backdrop of a Mickey Mouse adventure in the Museum of Modern Art, published in 1947, become real works. Kelley writes: "Art must concern itself with the real, but it throws any notion of the real into question. It always turns the real into a facade, a representation, and a construction. But it also raises questions about the motives of that construction."[11] And these "motives" are expressed by mental frames, pedestals, and glass cases. By cutting out cultural or social forms (votive sculptures, cartoons, theater sets, drawings by abused children) and placing them in another context, Kelley uses forms as cognitive tools, freed from their original packaging.

John Armleder manipulates similarly heterogeneous sources: mass-produced objects, stylistic markers, works of art, furniture. He might pass for the prototype of the postmodern artist; above all, he was among the first to understand that the modern notion of the *new* needed to be replaced with a more useful notion as quickly as possible.

11 *MIKE KELLEY,* OP. CIT.

After all, he explains, the idea of newness was merely a stimulus. It seemed inconceivable to him "to go to the country, sit down in front of an oak tree and say: 'but I've already seen that!'"[12] The end of the modernist *telos* (the notions of progress and the avant-garde) opens a new space for thought: now what is at stake is to positivize the remake, to articulate uses, to place forms in relation to each other, rather than to embark on the heroic quest for the forbidden and the sublime that characterized modernism. Armleder relates acquiring objects and arranging them in a certain way – the art of shopping and display – to the cinematic productions pejoratively referred to as B-movies. A B-movie is inscribed within an established genre (the western, the horror film, the thriller) of which it is a cheap by-product, while remaining free to introduce variants in this rigid framework, which both allows it to exist and limits it. For Armleder, modern art as a whole constitutes a bygone genre we can play with, the way Don Siegel, Jean-Pierre Melville, John Woo, or Quentin Tarantino take pleasure in abusing the conventions of film noir. Armleder's works testify to a shifted use of forms, based on a principle of mise-en-scène that favors the *tensions* between commonplace elements and more serious items: a kitchen chair is placed under an abstract, geometrical painting, spurts of paint in the style of Larry Poons run alongside an electric guitar. The austere and minimalist aspect of Armleder's works from the eighties reflect the clichés inherent in this B-movie modernism. "It might seem that I buy pieces of furniture for their formal virtues, and from a formalist perspective," Armleder explains. "You might say that the choice of an object has to do with an *overall* decision that is formalist, but this system favors decisions that are completely external to form: my final choice makes fun of the somewhat rigid system that I use to start with. If I am looking for a Bauhaus sofa of a certain length, I might end up bringing back

12 JOHN ARMLEDER IN CONVERSATION WITH NICOLAS BOURRIAUD AND ERIC TRONCY, *DOCUMENTS SUR L'ART*, NO. 6, FALL 1994.

a Louis XVI. My work undermines itself: all the theoretical reasons end up being negated or mocked by the execution of the work."[13] In Armleder's work, the juxtaposition of abstract paintings and post-Bauhaus furniture transforms these objects into rhythmic elements, just as the "selector" in the early days of hip-hop mixed two records with the crossfader of the mixing board. "A painting by Bernard Buffet alone is not very good, but a painting by Bernard Buffet with a Jan Vercruysse becomes extraordinary."[14] The early nineties saw Armleder's work lean toward a more open use of subculture. Disco balls, a well of tires, videos of B-movies – the work of art became the site of a permanent *scratching*. When Armleder placed Lynda Benglis's Plexiglas sculptures from the seventies against a background of Op-art wallpaper, he functioned as a remixer of realities.

Bertrand Lavier functions in a similar way when he superimposes a refrigerator onto an armchair (Brandt on Rue de Passy) or one perfume onto another (Chanel No. 5 on Shalimar), grafting objects in a playful questioning of the category of "sculpture." His *TV Painting,* 1986, shows seven paintings by Jean Fautrier, Charles Lapicque, Nicolas De Staël, Lewensberg, On Kawara, Yves Klein, and Lucio Fontana, each broadcast by a television set whose size corresponds to the format of the original work. In Lavier's work, categories, genres, and modes of representation are what generate forms and not the reverse. Photographic framing thus produces a sculpture, not a photograph. The idea of "painting a piano" results in a piano covered in a layer of expressionistic paint. The sight of a whitened store window generates an abstract painting. Like Armleder and Kelley, Lavier takes as material the established categories that delimit our perception of culture. Armleder considers them subgenres in the B-movie of modernism; Kelley deconstructs their figures and compares them with the practices

13 IBID.

14 IBID.

of popular culture; Lavier shows how artistic categories (painting, sculpture, photography), treated ironically as undeniable facts, produce the very forms that constitute their own subtle critique.

It might seem that these strategies of reactivation and the deejaying of visual forms represent a reaction to the overproduction or inflation of images. The world is saturated with objects, as Douglas Huebler said in the sixties, adding that he did not wish to produce more. While the chaotic proliferation of production led Conceptual artists to the dematerialization of the work of art, it leads postproduction artists toward strategies of mixing and combining products. Overproduction is no longer seen as a *problem,* but as a cultural ecosystem.

WHEN SCREENPLAYS BECOME FORM: A USER'S GUIDE TO THE WORLD
Postproduction artists invent new uses for works, including audio or visual forms of the past, within their own constructions. But they also reedit historical or ideological narratives, inserting the elements that compose them into alternative scenarios.

Human society is structured by narratives, immaterial *scenarios,* which are more or less claimed as such and are translated by lifestyles, relationships to work or leisure, institutions, and ideologies. Economic decision-makers project scenarios onto the world market. Political authorities devise plans and discourses for the future. We live within these narratives. Thus, the division of labor is the dominant employment scenario; the heterosexual married couple, the dominant sexual scenario; television and tourism, the favored leisure scenario. "We are all caught within the scenario play of late capitalism," writes Liam Gillick. "Some artists manipulate the techniques of 'prevision' so as to let the motivation show."[15] For artists today contributing to the birth of a *culture of activity,* the forms that surround us are the materializations of these narratives. Folded and hidden away in all cultural products

as well as in our everyday surroundings, these narratives reproduce communal scenarios that are more or less implicit: a cell phone, an article of clothing, the credits of a television show, and a company logo all spur behaviors and promote collective values and visions of the world.

Gillick's works question the dividing line between fiction and fact by redistributing these two notions via the concept of the scenario. This is seen from a social point of view, as a set of discourses of forecasting and planning by which the socioeconomic universe and the imagination factories of Hollywood invent the present. "The production of scenarios is one of the key components in maintaining the level of mobility and reinvention required to provide the dynamic aura of so-called free-market economies."[16]

Postproduction artists use these forms to decode and produce different story lines and alternative narratives. Just as through psychoanalysis our unconscious tries, as best it can, to escape the presumed fatality of the familial narrative, art brings collective scenarios to consciousness and offers us other pathways through reality, with the help of forms themselves, which make these imposed narratives material.

By manipulating the shattered forms of the collective scenario, that is, by considering them not indisputable facts but precarious structures to be used as tools, these artists produce singular narrative spaces of which their work is the mise-en-scène. It is the use of the world that allows one to create new narratives, while its passive contemplation relegates human productions to the communal spectacle. There is not living creation, on the one hand, and the dead weight of the

15 LIAM GILLICK, "SHOULD THE FUTURE HELP THE PAST?" IN *DOMINIQUE GONZALEZ-FOERSTER, PIERRE HUYGHE, PHILIPPE PARRENO,* P.17. REPRINTED IN *FIVE OR SIX* (NEW YORK: LUKAS & STERNBERG, 1999), P. 40.

16 IBID., P. 9.

history of forms, on the other: postproduction artists do not make a distinction between their work and that of others, or between their own gestures and those of viewers.

RIRKRIT TIRAVANIJA

In the works of Pierre Huyghe, Liam Gillick, Dominique Gonzalez-Foerster, Jorge Pardo, and Philippe Parreno, the artwork represents the site of a negotiation between reality and fiction, narrative and commentary. The viewer of an exhibition by Rirkrit Tiravanija such as *Untitled (One Revolution Per Minute),* 1996, will spend some time trying to distinguish the border between the artist's production and his or her own. A crepe stand, surrounded by a table filled with visitors, sits at the center of a labyrinth made of benches, catalogs, and tapestries; paintings and sculptures from the eighties accentuate the space. Where does the kitchen stop, and where does the art begin, when the work consists essentially of the consumption of a dish, and visitors are encouraged to carry out everyday gestures just as the artist is doing? This exhibition clearly manifests a will to invent new connections between artistic activity and a set of human activities by constructing a narrative space that captures quotidian tasks and structures in script form, as different from traditional art as the rave is from the rock concert.

The title of a work by Tiravanija is nearly always accompanied by the parenthetical mention of "lots of people." People are one of the components of the exhibition. Rather than being limited to viewing a set of objects offered for their appreciation, they are invited to mingle and to help themselves. The meaning of the exhibition is constituted by the use its "population" makes of it, just as a recipe takes on meaning when a tangible reality is formed: spaces meant for the performance of everyday functions (playing music, eating, resting, reading, talking) become artworks, objects. The visitor at an exhibition by Tiravanija is thus faced with the process that constitutes the meaning

of his or her own life, through a parallel (and similar) process that constitutes the meaning of the work. Like a movie director, Tiravanija is by turns active and passive, urging actors to adopt a specific attitude, then letting them improvise; helping out in the kitchen before leaving behind a simple recipe or leftovers. He produces modes of sociality that are partially unforeseeable, a *relational aesthetic* whose primary characteristic is mobility. His work is made of temporary campsites, bivouacs, workshops, encounters, and trajectories: the true subject of Tiravanija's work is nomadism, and it is through the problematics of travel that one can clearly envision his formal universe. In Madrid, he filmed the trip between the airport and the Reina Sofia Center where he was participating in an exhibition (*Untitled, para Cuellos de Jarama to Torrejon de ardoz to Coslada to Reina Sofia,* 1994). For the Lyon Biennial, he presented the car that brought him to the museum (*Bon Voyage, Monsieur Ackermann,* 1995). *On the road with Jiew, Jeaw, Jieb, Sri and Moo,* 1998, consisted of a cross-country road trip from Los Angeles to Philadelphia, the exhibition site, with five students from Chiang Mai University. This long drive was documented with video, photographs, and a travel diary on the Internet; it was presented at the Philadelphia Museum of Art and resulted in a catalog on CD-ROM. Tiravanija also reconstructs the architectural structures he has visited, the way an immigrant might take stock of the places he has left behind: his apartment on the Lower East Side rebuilt in Cologne, one of the eight studios at Context Studio in New York rebuilt at the Whitney Museum of Art ("Rehearsal Studio No. 6"), the Gavin Brown gallery transformed into a rehearsal space in Amsterdam. His work shows us a world made up of hotel rooms, restaurants, stores, cafes, workplaces, meeting places and encampments (the tent of *Cinéma de ville,* 1998). The types of spaces Tiravanija proposes are those that shape the everyday life of the uprooted traveler: they are all public spaces, with the exception of his own apartment, whose form accompanies him abroad like a phantom from his past life.

Tiravanija's art always has something to do with giving, or with the opening of a space. He offers us the forms of his past and his tools and transforms the places where he is exhibiting into places accessible to all, as during his first New York show (in 1993), for which he invited the homeless to come in and eat soup. This immediate generosity might be likened to the Thai culture in which Buddhist monks do not work but are encouraged to accept people's gifts.

Precariousness is at the center of a formal universe in which nothing is durable, everything is movement: the trajectory between two places is favored in relation to the place itself, and encounters are more important than the individuals who compose them. Musicians at a jam session, customers at a cafe or restaurant, children at a school, audience members at a puppet show, guests at a dinner: these temporary communities are organized and materialized in structures that are so many human attractors. By bringing together notions of community and ephemerality, Tiravanija counters the idea that an identity is indissoluble or permanent: our ethnicity, our national culture, our personality itself are just baggage that we carry around. The nomads that Tiravanija's work describes are allergic to national, sexual, and tribal classifications. Citizens of international public space, they traverse these spaces for a set amount of time before adopting new identities; they are universally *exotic*. They make the acquaintance of people of all sorts, the way one might hook up with strangers during a long trip. That is why one of the formal models of Tiravanija's work is the airport, a transitional place in which individuals go from boutique to boutique and from information desk to information desk and join the temporary micro-communities that gather while waiting to reach a destination. Tiravanija's works are the accessories and decor of a planetary scenario, a script in progress whose subject is how to inhabit the world without residing anywhere.

PIERRE HUYGHE

While Tiravanija offers us models of possible narratives whose forms
blend art and everyday life, Pierre Huyghe organizes his work as a
critique of the narrative models offered us by society. Sitcoms, for
example, provide a mass audience with imaginary contexts with
which it can identify. The scripts are written based on what is called
a *bible*, a document that specifies the general nature of the action and
the characters, and the framework in which these must evolve.
The world that Huyghe describes is based on constraining narrative
structures, whose "soft" version is the sitcom; the function of artistic
practice is to make these structures function in order to reveal their
coercive logic and then to make them available to an audience likely
to reappropriate them. This vision of the world is not far removed
from Michel Foucault's theory of the organization of power: from top
to bottom of the social scale, a "micropolitics" reflects ideological
fictions that prescribe ways of living and tacitly organize a system of
domination. In 1996, Huyghe offered fragments of screenplays by
Stanley Kubrick, Jacques Tati, and Jean-Luc Godard to participants
in his casting sessions (*Multiple Scenarios*). An individual reading the
screenplay for *2001: A Space Odyssey* on a stage only amplifies a
process that traverses the entirety of our social life: we recite a text
written *elsewhere*. And this text is called an ideology. The challenge,
then, is to learn to become the critical interpreter of this ideological
scenario, by playing with other scenarios and by constructing situation
comedies that will eventually be superimposed on the narratives
imposed on us. Huyghe's work aims to bring to light these implicit
scenarios and to invent others that would make us freer: citizens
would gain autonomy and freedom if they could participate in the
construction of the "bible" of the social sitcom instead of deciphering
its lines.

By photographing construction workers on the job, then exhibiting this
image on an urban billboard overlooking the construction site for

50

the duration of the project (*Chantier Barbès-Rochechouart,* 1994), Huyghe offers an image of labor in real time: the activity of a group of workers on a construction site is seldom documented, and the representation here doubles or dubs it the way live commentary would. In Huyghe's work, delayed representation is the primary site of social falsification: the issue is not only to restore speech to individuals but also to show the invisible work of dubbing while it is being done. *Dubbing,* 1996, a video in which actors dub a film in French, plainly illuminates this general process of dispossession: the grain of the voice represents and manifests the singularity of speech that the imperatives of globalized communication force one to eradicate. It is the subtitle versus the original version, the global standardization of codes. This ambition in some ways recalls Godard of the militant years, when he planned to reshoot *Love Story* and distribute cameras to factory workers in order to thwart the bourgeois image of the world, this falsified image that the bourgeoisie calls a "reflection of the real." "Sometimes," Godard writes, "the class struggle is the struggle of one image against another image and one sound against another sound."[17] In this spirit, Huyghe produced a film (*Blanche Neige Lucie,* 1997) about Lucie Dolène, a French singer whose voice was used by the Disney studios for the dubbed version of *Snow White,* in which Lucie tries to obtain the rights to her voice. A similar process governs the artist's version of Sidney Lumet's 1975 film *Dog Day Afternoon,* in which the protagonist of the original bank robbery (to which Lumet bought the rights) finally has the opportunity to play his own role, one that was confiscated by Al Pacino: in both cases, individuals reappropriate their story and their work, and reality takes revenge on fiction. All of Huyghe's work, for that matter, resides in this interstice that separates reality from fiction and is sustained by its activism in favor of a democracy of social sound tracks: dubbing versus redubbing.

17 JEAN-LUC GODARD, *GODARD PAR GODARD, DES ANNÉES MAO AUX ANNÉES 80* (PARIS: FLAMMARION, 1991).

Fiction's swing toward reality creates gaps in the spectacle. "The question is raised of whether the actors might not have become interpreters," says Huyghe, regarding his billboards of workers or passersby exhibited in urban space. We must stop interpreting the world, stop playing walk-on parts in a script written by power. We must become its actors or co-writers. The same goes for works of art: when Huyghe reshoots a film by Alfred Hitchcock or Pier Paolo Pasolini shot by shot or juxtaposes a film by Warhol with a recorded interview with John Giorno, it means that he considers himself responsible for their work, that he restores their dimension as scores to be replayed, tools allowing the comprehension of the current world. Pardo expresses a similar idea when he states that many things are more interesting than his work, but that his works are "a model for looking at things." Huyghe and Pardo restore works of the past to the world of *activity*. Through pirate television (*Mobile TV,* 1995-98), casting sessions, or the creation of the *Association des Temps libérés* (Association of Freed Time), Huyghe fabricates structures that break the chain of interpretation in favor of forms of activity: within these setups, exchange itself becomes the site of use, and the script-form becomes a possibility of redefining the division between leisure and work that the collective scenario upholds. Huyghe works as a *monteur,* or film editor. And *montage,* writes Godard, is a "fundamental political notion. An image is never alone, it only exists on a background (ideology) or in relation to those that precede or follow it."[18] By producing images that are *lacking* in our comprehension of the real, Huyghe carries out political work: contrary to the received idea, we are not saturated with images, but subjected to the lack of certain images, which must be produced to fill in the blanks of the official image of the community.

Fenêtre sur cour (Rear Window), 1995, is a video shot in a Parisian apartment building that repeats the action and dialogue of Hitchcock's

18 IBID.

film shot by shot, reinterpreted in its entirety by young French actors and set in a Parisian housing project. The "remake" affirms the idea of a production of models that can be replayed endlessly, a synopsis available for everyday activity.

The unfinished houses that serve as sets for *Incivils,* 1995, a "remake" of Pasolini's *Uccellacci e uccelini,* represent "a provisional state, a suspended time," since these buildings have been left unfinished in order for their owners to avoid Italian tax laws. In 1996, Huyghe offered visitors of the exhibition *Traffic* a bus ride toward the docks of Bordeaux. Throughout their nighttime trip, travelers could view a video that showed the image of the route they were following, shot in the daytime. This shift between night and day, as well as the slight delay due to red lights and traffic, introduced an uncertainty concerning the reality of the experience: the superimposition of real time and the mise-en-scène produced a potential narrative. While the image becomes a tenuous link that connects us to reality, a splintered guide to the lived experience, the meaning of the work has to do with a system of differences: the difference between the direct and the deferred, between a piece by Gordon Matta-Clark or a film by Warhol and the projection of these works by Huyghe, between three versions of the same film (*L'Atlantique*), between the image of work and the reality of this work (*Barbès-Rochechouart*), between the meaning of a sentence and its translation (*Dubbing*), between a lived moment and its scripted version (*Dog Day Afternoon*). It is in difference that human experience occurs. Art is the product of a gap.

By refilming a movie shot by shot, we represent something other than what was dealt with in the original work. We show the time that has passed, but above all we manifest a capacity to evolve among signs, to inhabit them. Reshooting Hitchcock's classic *Rear Window* in a Parisian housing project with unknown actors, Huyghe exposes a skeleton of action rid of its Hollywood aura, thereby asserting a conception

of art as the production of models that may be endlessly repeated, scenarios for everyday action. Why not use a fiction film to look at construction workers erecting a building just outside our window? And why not bring together the words of Pasolini's *Uccellacci e uccelini* and a few unfinished buildings in a contemporary Italian suburb? Why not use art to look at the world, rather than stare sullenly at the forms it presents?

DOMINIQUE GONZALEZ-FOERSTER

Dominique Gonzalez-Foerster's "Chambres" series, home movies and impressionist environments, sometimes strike the critic as too intimate or too atmospheric. Yet she explores the domestic sphere by placing it in relation with the most burning social questions; the fact is that she works on the *grain* of the image more than on its composition. Her installations set in motion atmospheres, climates, inexpressible sensations of art, through a catalog of often blurry or unframed images – images in the midst of being focused. In front of a piece by Gonzalez-Foerster, it is the viewer's task to blend the whole sensorially, the way a viewer's eye must optically blend the pointillist stipplings of a Seurat. With her short film *Riyo,* 1998, it is even up to the viewer to imagine the features of the protagonists, whose faces are never presented to us, and whose phone conversation follows the course of a boat ride on a river across Kyoto. The facades of buildings filmed in a continuous shot provide the framework of the action; as in all of her work, the sphere of intimacy is literally projected onto common objects and rooms, souvenir images, and floor plans of houses. She is not content to show the contemporary individual grappling with his or her private obsessions, but instead reveals the complex structures of the mental cinema through which this individual gives shape to his or her experience: what the artist calls *automontage,* which starts with an observation on the evolution of our ways of living.

"The technologization of our interiors," Gonzalez-Foerster writes, "transforms our relationship to sounds and images,"[19] and turns the individual into a sort of editing table or mixing board, the programmer of a home movie, the inhabitant of a permanent film set. Here again, we are faced with a problematic that compares the world of work and that of technology, considered a source of the re-enchantment of the everyday and a mode of production of the self. Her work is a landscape in which machines have become objects that can be appropriated, domesticated. Gonzalez-Foerster shows the end of technology as an apparatus of the state, its pulverization in everyday life via such forms as computer diaries, radio alarm clocks, and digital cameras used as pens. For Gonzalez-Foerster, domestic space represents not a site of withdrawal into the self but a site of confrontation between social scripts and private desires, between received images and projected images. It is a space of projection. All domestic interiors function on the basis of a narrative of the self; they make up a scripted version of everyday life as well as an analysis: recreating the apartment of filmmaker Rainer Werner Fassbinder (*RWF,* 1993), rooms that have been lived in, seventies decor, or a walk through a park. Gonzalez-Foerster uses psychoanalysis in numerous projects as a technique that allows the emergence of a new scenario: faced with a blocked personal reality, the analysand works to reconstruct the narrative of his or her life on the unconscious level, allowing the mastery of images, behaviors, and forms that, until then, have eluded him or her. The artist asks the visitor of the exhibition to trace the floor plan of the house he or she inhabited as a child, or asks the gallerist Esther Schipper to entrust her with childhood objects and memories. The primary locus of experience for Gonzalez-Foerster is the bedroom: reduced to an affective skeleton (a few objects, colors), she materializes the act of memory – both emotional and aesthetic

19 DOMINIQUE GONZALEZ-FOERSTER, "TROPICALITY" IN *DOMINIQUE GONZALEZ-FOERSTER, PIERRE HUYGHE, PHILIPPE PARRENO,* P. 122.

memory, referencing Minimalist art in her aesthetic organization.

Her universe composed of affective objects and colored floor plans is similar to the experimental films and home movies of Jonas Mekas: Gonzalez-Foerster's work, which is striking in its homogeneity, seems to constitute a film of domestic forms on which images are projected. She presents structures where memories, places, and everyday facts are inscribed. This mental film is the object of more elaborate treatment than the narrative structure, itself sufficiently open to accommodate the viewer's lived experience, indeed, to provoke his or her own memory, as in a psychoanalytical session. Should we, in the presence of her work, practice the *floating gaze,* analogous to the *floating listening* through which analysts facilitate the flow of memories? Gonzalez-Foerster's works are characterized by this vagueness – at once intimate and impersonal, austere and free – that blurs the contours of all narratives of everyday life.

LIAM GILLICK

Liam Gillick's work presents itself as an ensemble of layers (archives, stage sets, posters, billboards, books) from which he produces pieces that might make up the set of a film or the materialization of a script. In other words, the narrative that constitutes his work circulates around and through the objects he exhibits, without these objects being merely illustrative. Each work functions as a folded scenario that contains indexes from areas of parallel knowledge (art, industry, urbanism, politics, and so on). Through individuals who played a major role in history while remaining in the shadows (Ibuka, the former vice chairman of Sony; Erasmus Darwin, the libertarian brother of the evolutionist; Robert McNamara, secretary of defense during the Vietnam War), Gillick fabricates tools of exploration that target the intelligibility of our era. A part of his work aims to destroy the border between the narrative arrangements of fiction and those of historical interpretation, to establish new connections between documentary and fiction.

A sense of the artwork as analytical of scenarios allows him to sub-stitute the historian's empirical succession ("this is what happened") with narratives that propose alternative possibilities of thinking about the current world, usable scenarios and courses of action. The real, to really be thought, must be inserted into fictional narratives; the work of art, which inserts social facts into the fiction of a coherent world, must in turn generate potential uses of this world, a mental logistics that favors change. Like the exhibitions of Tiravanija, those of Gillick imply the participation of the audience: his work is composed of negotiation tables, discussion platforms, empty stages, bulletin boards, drawing tables, screens, and information rooms – collective, open structures. "I try to encourage people," he writes, "to accept that the work of art presented in a gallery is not the resolution of ideas and objects." By maintaining the myth of the artwork as a problem re-solved, we annihilate the action of the individual or groups on history. If the forms Gillick exhibits closely resemble the decor of everyday alienation (logos, elements from bureaucratic archives or offices, conference rooms, specific spaces of economic abstraction), their titles and the narratives they refer to evoke decisions to be made, uncertainties, possible engagements. The forms he produces always seem suspended; there is an ambiguity to how "finished" or "unfin-ished" they are. For his exhibition *Erasmus is late* in Berlin, 1996, each wall in the Schipper & Krome gallery was painted a different color, but the layer of paint stopped midway, the brushstrokes obvious. Nothing is more violently foreign to the industrial world than incomple-tion, than quickly assembled tables or abandoned paint jobs. A man-ufactured object cannot be incomplete in this way. The "incomplete" status of Gillick's works raises the question: at what point in the development of the industrial process did mechanization destroy the last traces of human intervention? What role does modern art play in this process? Modes of mass production destroy the object as scenario in order to assert its foreseeable, controllable, routine char-acter. We must reintroduce the unforeseeable, the uncertainty, *play:*

thus certain of Gillick's pieces may be produced by others, in the functionalist tradition inaugurated by László Moholy-Nagy. *Inside now, we walked into a room with Coca-Cola painted walls,* 1998, is a wall drawing that must be painted by several assistants, according to precise rules: the object is to approximate the color of the famous soda, brushstroke by brushstroke; the soda's mode of production follows exactly the same process, since it is produced by local factories based on the formula provided by the Coca-Cola Company. For an exhibition he curated at Gio Marconi Gallery in 1992, Gillick asked sixteen English artists to send him instructions so that he could produce their pieces himself on site.

The materials Gillick uses are derived from corporate architecture: Plexiglas, steel, cables, treated wood, and colored aluminum. By connecting the aesthetic of Minimalist art with the muted design of multinational corporations, the artist draws a parallel between universalistic modernism and Reaganomics, the project of emancipation of the avant-gardes and the protocol of our alienation in a modern economy. Parallel structures: Tony Smith's *Black Box* becomes Gillick's "projected think tank." The documentation tables found in Conceptual art exhibitions organized by Seth Siegelaub are used here to read fiction; Minimalist sculpture is transformed into an element of role playing. The modernist grid issued from the utopia of Bauhaus and Constructivism is confronted with its political reprocessing, i.e., the set of motifs by which economic power has established its domination. Weren't Bauhaus students the ones who conceived of the "Atlantic Wall" bunkers during World War II? This archaeology of modernism is particularly visible in a series of pieces produced on the basis of Gillick's book *Discussion Island Big Conference Center* (1997), fiction that presents a "think tank on think tanks." Indexing Donald Judd's formal vocabulary and installed on the ceiling, these pieces bear titles that refer to functions carried out in a corporate context: *Discussion Island Resignation Platform, Conference Screen, Dialogue Platform,*

Moderation Platform, and so on. The phenomenology dear to Minimalist artists becomes a monstrous bureaucratic behaviorism, Gestalt an advertising procedure. Gillick's works, like those of Carl Andre, represent zones more than sculptures: here, one is meant to resign, discuss, project images, speak, legislate, negotiate, take advice, direct, prepare something, and so on. But these forms, which project possible scenarios, imply the creation of new scenarios.

MAURIZIO CATTELAN

In *Untitled,* 1993, the canvas is lacerated three times in the shape of a Z, an allusion to the Z of Zorro in the style of Lucio Fontana. In this apparently very simple work, at once minimalist and immediately accessible, we find all the figures that compose Cattelan's work: the exaggerated *détournement* of works of the past, the moralist fable, and, above all, the insolent way of breaking into the value system, which remains the primary feature of his style and which involves taking forms literally. While the laceration of a canvas for Fontana is a symbolic and transgressive act, Cattelan shows us this act in its most current acceptation, the use of a weapon, and as the gesture of a comic villain. Fontana's vertical gesture opened onto the infiniteness of space, onto the modernist optimism that imagined a place beyond the canvas, the sublime within reach. Its reprise (in zigzags) by Cattelan mocks the Fontana by indexing the work to a Walt Disney television series about Zorro, quasi-contemporary to it. The zigzag is the most frequently used movement in Cattelan's work: it is comic and Chaplinesque in its essence, and it corresponds to errancy, or waywardness. The artist as slalom racer may be tricky, his uncertain bearing may be laughable, but he encircles the forms he brushes up against while dispatching them to their status as accessory and decor. *Untitled* is certainly a programmatic work, from the viewpoint of form as well as method: the zigzag is Cattelan's sign. If we consider the artist's numerous "remakes" of other artists' works, we notice that the method is always identical: the formal structure

seems familiar, but layers of meaning appear almost insidiously, radically overturning our perception. Cattelan's forms always show us familiar elements dubbed, in voice-over, by cruel or sarcastic anecdotes. In *Mon Oncle* by Jacques Tati, a man sees a concierge pluck a chicken. He then imitates the cackling of the animal, making the poor woman jump as she is persuaded that it has come back to life. Many of Cattelan's works produce an analogous effect, when he creates "sound tracks" for works – Zorro's song for a Fontana, the Red Brigade for a work that evokes Robert Smithson or Jannis Kounellis, tomblike reflection before a hole in the style of the earthworks of the sixties. When he installed a live donkey in a New York gallery beneath a crystal chandelier in 1993, Cattelan indirectly alluded to the twelve horses that Kounellis exhibited at the Attico gallery in Rome in 1969. But the title of the work (*Warning! Enter at your own risk. Do not touch, do not feed, no smoking, no photographs, no dogs, thank you*) radically reverses the work's meaning, ridding it of its historicity and its vitalist symbolism to turn it toward the system of representation in the most spectacular sense of the term: what we are seeing is a burlesque spectacle under high surveillance whose outer limits are purely legal. The live animal is presented not as beautiful, or as new, but as both dangerous for the public and incredibly problematic for the gallerist. The reference to Kounellis is not gratuitous, as it seems clear that Arte Povera represents the principal formal matrix of Cattelan's work, with regard to the composition of his images and the spatial arrangement of readymade elements. The fact is that he rarely uses mass-produced objects, or technology. His formal register is composed of more natural elements (Jannis Kounellis, Giuseppe Penone) or anthropomorphic ones (Giulio Paolini, Alighiero Boetti). It is not a matter of influences, much less an homage to Arte Povera, but a sort of linguistic "hard drive" that is quite discrete and that reflects Cattelan's Italian visual education.

In 1968, Pier Paolo Calzolari exhibited *Untitled (Malina),* an installation in which he presented an albino dog attached to the wall by a leash in an environment that featured a pile of earth and blocks of ice. One might think again of Cattelan's menagerie of horses, donkeys, dogs, ostriches, pigeons, and squirrels – except that his animals do not symbolize anything or refer to any transcendent value, but merely embody types, personages, or situations. The symbolic universe developed by Arte Povera or Joseph Beuys disintegrates in Cattelan's work under the pressure of a troublemaker who constantly compares forms and their contradictions and violently refuses any positive value.

This way of turning modernist forms against the ideologies that saw them emerge – the modern ideologies of emancipation, of the sublime – as well as against the art world and its beliefs, testifies more to Cattelan's caricatured ferocity than to a so-called cynicism. Some of his exhibitions might at first glance evoke a Michael Asher or Jon Knight, insofar as they reveal the economic and social structures of the art system by centering on the gallerist or the exhibition space. But very quickly, the conceptual reference gives way to another, more diffuse impression, that of a real personalization of criticism, which refers to the form of the fable as well as to a real will for nuisance. In 1993, Cattelan produced a piece that occupied the entire Massimo de Carlo gallery in Milan; it could only be viewed from the window. After explaining his idea in an interview, the artist concluded by admitting: "I also wanted to see Massimo de Carlo outside the gallery for a month." A troublemaker, the eternal bad student skulking at the back of the classroom. We have the impression that Cattelan considers his formal repertoire as piles of homework to be completed, a set of imposed figures, a sort of detention which the artist/dunce takes pleasure in turning into a joke. One of his earliest significant pieces, *Edizioni dell'obligio,* 1991, was composed of schoolbooks whose covers and titles had been modified by children, a sort of

scornful revenge against any agenda. As for the draperies and fabrics of Arte Povera and the Anti-form of the sixties, they were used to escape from the Castello di Rivara, where he was participating in his first important group show in 1992: "I enjoyed watching what the other artists were doing, how they reacted to the situation. That work was not only metaphorical, it was also a tool. The night before the opening, I let myself down from the window and I ran away." The work presented was nothing other than a makeshift ladder made of knotted sheets, hanging on the facade of the exhibition site. Following the same principle, during Manifesta II in Luxembourg in 1998, Cattelan exhibited an olive tree planted on an enormous diamond of earth. A hurried observer might have thought it a remake of Beuys or Penone; yet this vegetal element ultimately had nothing to do with the meaning of the work, which was articulated around the offensive syntax developed by the artist: to pinpoint the physical and ideological limits of individuals and communities, to test the possibilities and patience of institutions.

Felix Gonzalez-Torres used historicized forms to reveal their ideological foundations and to construct a new alphabet to struggle against sexual norms. Cattelan pushes the forms that he manipulates toward conflict and comedy: seeking out conflicts with operators of the art system through works that are ever more embarrassing, constricting, or cumbersome, and highlighting the comedy that underlies the power relations in this system through the intermediary of narratives that derail the recent history of art toward the burlesque. In a word, his behavior as an artist involves guiding the forms he manipulates toward delinquency.

PIERRE JOSEPH: LITTLE DEMOCRACY
Our lives unfold against a changing background of images and amid a flux of data that envelops everyday life. Images are formatted like products or are used to sell other objects; masses of data circulate.

Pierre Joseph's artistic project consists of inscribing meaning within this environment: it is not another critical position, but a productive practice, analogous to one that makes its way through a network, establishes an itinerary, and surfs. Joseph deals primarily with the conditions of the appearance and functioning of images, starting from the postulate that, these days, we reside within an enormous image zone, rather than in front of images: art is not another spectacle but an exercise of *détourage*. He develops a playful and instrumental relationship with forms, which he manipulates, samples, and adapts to new uses, establishing different processes of reanimation. Minimalist art thus serves as a set for *Cache cache killer,* 1991. Abstract art decorates an exhibition in the form of a treasure hunt (*La chasse au trésor ou l'aventure du spectateur disponible* [The Treasure Hunt or the Adventure of the Available Spectator], 1993), and the works of Robert Delaunay and Maurizio Nannucci are recycled as backdrops for new scenes in a film in which Joseph's "reanimated characters" wander about. In 1992, he remade pieces that interested him by Lucio Fontana, Jasper Johns, Helio Oiticica, and Richard Prince. This instrumentalization of culture does not stem from a casual attitude in relation to history; quite the contrary, it establishes the conditions for free behavior in a society of managed consumption. In Joseph's work, the recycling of forms and images constitutes the basis of an ethics: we must invent ways of inhabiting the world. In the political sphere, submission to form has a name: dictatorship. A democracy, on the other hand, calls for constant role play, endless discussion, and negotiation. That Joseph chose the title *Little Democracy* to refer to the set of live "reanimated characters" seems completely logical. These characters, the first of which appeared in 1991, are presented in the form of an outfit worn by an extra. They are "installed" in the gallery or museum like any other work, on the evening of the show's opening: then they are replaced by a photograph, an index allowing the future owner to "reanimate" the piece at his leisure. These characters come from the image-system

of mythology, video games, comic strips, movies, and advertising: Superman, Catwoman, "color stealers" from a Kodak commercial, a paintballer, Casper the Ghost, or a replicant from *Blade Runner*. Sometimes, a slightly macabre element causes a shift: the surfer is dead, an injured character wears a bandage around his head, the ground where Superman stands is littered with cigarette butts and beer bottles, the cowboy lies face down. Some are presented against their true backgrounds: the blue of a bluescreen used for video super-imposition, manifesting at once the characters' unreality and their potential for displacement onto various backgrounds and into endless scenarios. Others are presented as actors in an iconographic role play, wandering around the museum or the space of a group exhibition, surrounded by other works: after Duchamp, who intended to "use a Rembrandt as an ironing board," Joseph places his characters amid modern art that has become decor. His work always aims for the horizon of an exhibition in which the audience is hero: the art becomes a special effect in an interactive mise-en-scène. The process of reanimating the figure is twofold: it reanimates the works next to which the characters appear, and it makes the entire world a playground, a stage, or a set.

This system is also a political project: the artist speaks of the intelligent cohabitation of subjects and the backgrounds against which they move about, of the intelligent coexistence of human beings and the works they are given to admire. The reanimation of icons, which characterizes the gallery of stock characters that make up *Little Democracy,* represents a democratic form in its essence, without demagogy or ponderous demonstration. Joseph is suggesting that we inhabit pre-existing narratives and unceasingly refabricate the forms that suit us. Here the goal of the image is to introduce playacting into systems of representation to keep them from becoming frozen, to detach forms from the alienating background where they become stuck if we take them for granted. A superficial reading of the characters might lead

one to believe that Joseph is an artist of the unreal, of popular entertainments. Yet the fairy-tale figures, cartoon characters, and science fiction heroes that populate this democracy do not call for a flight from reality but urge us to experience our reality through fiction. In a complex stage management of live characters, Casper the Ghost, Cupid, and the fairy function as so many images *embedded* in the system of the division of labor: these imaginary beings, Joseph explains, obey "a cyclical, controlled, and unchanging program," and their functional status hardly differs from that of an assembly line worker at Renault, or a waiter in a restaurant who takes an order, serves a meal, and brings the bill. These characters are extremely typecast; they are robot-portraits, images perfectly associated with a model-character, with a defined function. The true mythology from which they arise is the ideology of the division of labor and the standardization of products. The realm of the imaginary, indexed to the regime of production, indiscriminately affects plumbers and superheroes. The fairy illuminates things with her magic wand, the auto worker adjusts parts on an assembly line: work is the same everywhere, and it is this world of unchanging processes and potential dead ends that Joseph describes; images provide a way out.

The images Joseph offers must be experienced: they must be appropriated and reanimated and included in new arrangements. In other words, meanings must be displaced. And tiny shifts create enormous movements. Why do so many artists strive to remake, recopy, dismantle, and reconstruct the components of our visual universe? What makes Pierre Huyghe reshoot Hitchcock and Pasolini? What compels Philippe Parreno to reconstruct an assembly line intended for leisure? To produce an alternative space and time, that is, to reintroduce the multiple and the possible into the closed circuit of the social, and for this, the artist must go back as far as possible in the collective machinery. With the help of installations that affect the exhibition site, Joseph offers us experimental objects, active products,

and artworks that suggest new ways of apprehending the real and new types of investment in the art world. *Little Democracy* is something we can inhabit.

THE USE OF THE WORLD

PLAYING THE WORLD: REPROGRAMMING SOCIAL FORMS

The exhibition is no longer the end result of a process, its "happy ending" (Parreno) but a place of production. The artist places tools at the public's disposal, the way Conceptual art events organized by Seth Siegelaub in the sixties placed information at the disposal of the visitor. Challenging established notions of the exhibition, the artists of the nineties envisaged the exhibition space as a space of cohabitation, an open stage somewhere between decor, film set, and information center.

In 1989, Dominique Gonzalez-Foerster, Bernard Joisten, Pierre Joseph, and Philippe Parreno presented *Ozone,* an exhibition in the form of "layers of information" on political ecology. The space was to be traversed by visitors in such a way that they could create their own visual montage. *Ozone* was offered as a "cinegenic space" whose ideal visitor would be an actor – an actor of information. The following year, in Nice, the exhibition *Les Ateliers du Paradis* was presented as a "film in real time." For the duration of the project, Joseph, Parreno, and Philippe Perrin inhabited the gallery space – which was fitted out with artworks from Angela Bulloch to Helmut Newton, gadgets, a trampoline, a Coke can that moved to the beat of music, and a selection of videos – a space in which they moved about according to a schedule (English lessons, a therapist's visit, and so on). On the evening of the opening, visitors were to wear a one-of-a-kind T-shirt on which a generic word or phrase figured (Good, Special Effect, Gothic), allowing the producer Marion Vernoux to draft a screenplay in real time. In short, it was an exhibition in real time, a browser launched in search of its contents. When Jorge Pardo produced his *Pier* in Munster in 1997, he constructed an apparently functional object,

but the real purpose of this wooden jetty had yet to be determined. Although Pardo presents everyday structures (tools, furniture, lamps), he does not assign them specific functions: it is quite possible that these objects are *useless*. What is there to do in an open shed at the end of a jetty? Smoke a cigarette, as the vending machine affixed to one of its walls encouraged? The visitor-viewer must invent functions and rummage through his or her own repertory of behaviors. Social reality provides Pardo with a set of utilitarian structures, which he reprograms according to artistic knowledge (composition) and a memory of forms (modernist painting).

From Andrea Zittel to Philippe Parreno, from Carsten Höller to Vanessa Beecroft, the generation of artists in question here intermingles Conceptual art and Pop art, Anti-form and Junk art, as well as certain procedures established by design, cinema, economy, and industry: it is impossible to separate the history of art from its social backdrop.

The ambitions, methods, and ideological postulates of these artists are not, however, so far removed from those of a Daniel Buren, a Dan Graham, or a Michael Asher twenty years earlier. They testify to a similar will to reveal the invisible structures of the ideological apparatus; they deconstruct systems of representation and revolve around a definition of art as visual information that destroys entertainment. The generation of Daniel Pflumm and Pierre Huyghe nevertheless differs from preceding ones on an essential point: they refuse metonymy, the stylistic figure that involves referring to a thing by one of its constituent elements (for example, to say "the rooftops" for "the city"). The social criticism in which Conceptual artists engaged passed through the filter of a critique of the institution: in order to show the functioning of the whole of society, they explored the specific site in which their activities unfolded, according to the principles of an analytical materialism that was Marxist in its inspiration. For instance, Hans Haacke denounced the multinationals by evoking the financing

of art; Asher worked with the architectural apparatus of the museum and the art gallery; Gordon Matta-Clark drilled through the floor of the Yvon Lambert gallery (*Descending Steps for Batan,* 1977); Robert Barry declared that the gallery showing him was closed (*Closed Gallery,* 1969).

While the exhibition site constituted a medium in and of itself for Conceptual artists, it has today become a place of production like any other. The task of the critic is now less to analyze or critique this space than to situate it in vaster systems of production, with which it must establish and codify relations. In 1991, Joseph made an end-less list of illegal or dangerous activities that took place in art centers (from "shooting at airplanes" [cf. Chris Burden] to "making graffiti," "destroying the building," and "working on Sunday"), which made it a "place for the simulation of virtual freedoms and experiences." A model, a laboratory, a playing field: whatever it was, it was never the symbol of anything, and certainly not a metonymy.

It is the *socius,* i.e., all the channels that distribute information and products, that is the true exhibition site for artists of the current gen-eration. The art center and the gallery are particular cases but form an integral part of a vaster ensemble: public space. Thus Pflumm exhibits his work indiscriminately in galleries, clubs, and any other structure of diffusion, from T-shirts to records that appear in the cata-log of his label Elektro Music Dept. He also produced a video on a very particular product, his own gallery in Berlin (*Neu,* 1999). Therefore, the issue is not to contrast the art gallery (a locus of "separate art," and therefore bad) with a public place imagined as ideal, where the "noble gaze" of passersby is naively fetishized the way the "noble savage" once was. The gallery is a place like any other, a space imbri-cated within a global mechanism, a base camp without which no expedition would be possible. A club, a school, or a street are not "better places," but simply other places.

More generally, it has become difficult for us to consider the social body as an organic whole. We perceive it as a set of structures detachable from one another, in the image of the contemporary body augmented with prostheses and modifiable at will. For artists of the late-twentieth century, society has become both a body divided into lobbies, quotas, and communities, and a vast catalog of narrative frameworks.

What we usually call reality is a montage. But is the one we live in the only possible one? From the same material (the everyday), we can produce different versions of reality. Contemporary art thus presents itself as an alternative editing table that shakes up social forms, reorganizes them, and inserts them into original scenarios. The artist deprograms in order to reprogram, suggesting that there are other possible uses for the techniques and tools at our disposal.

Gillian Wearing and Pierre Huyghe have each produced videos based on surveillance camera systems. Christine Hill created a travel agency in New York that functioned like any other travel agency. Michael Elmgreen and Ingar Dragset set up an art gallery in a museum during Manifesta 2000 in Slovenia. Alexander Györfi has used forms from the studio and the stage, Carsten Höller those of laboratory experiments. The obvious point in common among these artists and many of the most creative today resides in this capacity to use existing social forms.

All cultural and social structures represent nothing more than articles of clothing that can be slipped on, objects to be experienced and tested. Alix Lambert did this in *Wedding Piece,* a work documenting her five weddings in one day. Matthieu Laurette uses newspaper classified ads, television game shows, and marketing campaigns as the media for his work. Navin Rawanchaikul works on the taxi system the way others draw on paper. When Fabrice Hybert set up his

company, UR, he declared that he wanted "to make artistic use of the economy." Joseph Grigely exhibits messages and scraps of paper which he uses to communicate with others due to his deafness: he reprograms a physical handicap into a production process. Showing the concrete reality of his daily communication in his exhibitions, Grigely takes as the medium of his work the intersubjective sphere and gives form to his relational universe. We "hear the voices" of his entourage. The artist makes captions for the remarks. He reorganizes human words, fragments of speech, and written traces of conversations, in a sort of intimate sampling, a domestic ecology. The written note is a social form that is paid little attention, generally meant for home or office use. In Grigely's work, it is freed of its subordinate status and takes on the existential dimension of a vital tool of communication: included in his compositions, it participates in a polyphony that is born of a *détournement*.

In this way, social objects, from habits to institutions through the most banal structures, are pulled from their inertia. By slipping into the functional universe, art revives these objects or reveals their absurdity.

PHILIPPE PARRENO & ...
The originality of the group General Idea, formed in the early seventies, was to work with social formatting: corporations, television, magazines, advertising, fiction. "In my view," Philippe Parreno says, "they were the first to think of the exhibition not in terms of forms or objects but of formats. Formats of representation, of reading the world. The question that my work raises might be the following: what are the tools that allow one to understand the world?"[01]

Parreno's work starts from the principle that reality is structured like a language, and that art allows one to articulate this language. He

01 PHILIPPE PARRENO, "GENERAL IDEA" IN *DOCUMENTS SUR L'ART*, NO. 4, OCTOBER 1993, PP. 21-26.

also shows that all social criticism is doomed to failure if the artist is content to plaster his or her own language over the one spoken by authority. To denounce or "critique" the world? One can denounce nothing from the outside; one must first inhabit the form of what one wants to criticize. *Imitation* is subversive, much more so than discourses of frontal opposition that only make formal gestures of subversion. It is precisely this defiance toward critical attitudes in contemporary art that leads Parreno to adopt a posture that might be compared to Lacanian psychoanalysis. It is the unconscious, Jacques Lacan said, that interprets symptoms, and does so much better than the analyst. Louis Althusser said something similar from a Marxist perspective: real critique is a critique of existing reality by existing reality itself. Interpreting the world does not suffice; it must be transformed. It is this process that Parreno attempts, starting with the realm of images, which he believes play the same role in reality as symptoms do in an individual's unconscious. The question raised by a Freudian analysis is the following: How are the events in a life organized? What is the order of their repetition? Parreno questions reality in a similar way, through the work of subtitling social forms and systematically exploring the bonds that unite individuals, groups, and images.

It is not by chance that Parreno has integrated the dimension of collaboration as a major axis of his work: the unconscious, according to Lacan, is neither individual nor collective; it exists in the middle, in the encounter, which is the beginning of all narrative. A subject, "Parreno &" (Joseph, Cattelan, Gillick, Höller, Huyghe, to name a few of his collaborations), is constructed through exhibitions that are often presented as relational models, in which the copresence of various protagonists is negotiated through the construction of a script or story.

Thus, in Parreno's work, it is often the commentary that produces forms rather than the reverse: a scenario is dismantled so that a

new one can be constructed, for the interpretation of the world is a symptom like any other. In his video *Ou* (Or), 1997, an apparently banal scene (a young woman taking off her Disney T-shirt) generates a search for the conditions of its appearance. We see displayed on-screen, in a long rewind, the books, movies, and conversations that led to the production of an image that lasted only thirty seconds. Here, as in the psychoanalytical process or in the infinite discussions of the Talmud, commentary produces the narratives. The artist must not leave the responsibility of captioning his images to others, for captions are also images, ad infinitum.

One of Parreno's first works, *No More Reality,* 1991, already posited this problem by linking the notions of screenplay and protest. An imaginary sequence shows a demonstration composed of very young children armed with banners and placards, chanting the slogan "No more reality." The question was: what are the slogans or subtitles of the images that stream past today? The goal of a demonstration is to produce a collective image that sketches out political scenarios for the future. The installation *Speech Bubbles,* 1997, a cluster of helium-filled balloons in the shape of comic-book speech bubbles, was presented as a collection of "tools of protest allowing each person to write his own slogans and stand out within the group and thus from the image that would be its representation."[02] Parreno operates here in the interstice that separates an image from its caption, labor from its product, production from consumption. As reportage on individual freedom, his works tend to abolish the space that separates the production of objects and human beings, work and leisure. With *Werktische/L'établi* (Workbench), 1995, Parreno shifted the form of the assembly line toward hobbies one might engage in on a Sunday; with the project *No Ghost, Just a Shell,* 2000, made with Pierre Huyghe,

02 PHILIPPE PARRENO, "SPEECH BUBBLES", INTERVIEW BY PHILIPPE VERGNE, *ART PRESS*, NO. 264, JANUARY 2001, PP. 22-28.

he bought the rights to a Japanese *manga* character, Ann Lee, and made her speak about her career as an animated character; in a set of interventions gathered under the title *L'Homme public* (Public Man), Parreno provided the French impersonator Yves Lecoq with texts to recite in the voices of famous people, from Sylvester Stallone to the Pope. These three works function in a way similar to ventriloquism and masks: by placing social forms (hobbies, TV shows), images (a childhood memory, a *manga* character), and everyday objects in a position to reveal their origins and their fabrication process, Parreno exposes the unconscious of human production.

HACKING, WORK, AND FREE TIME

The practices of postproduction generate works that question the use of work. What becomes of work when professional activities are doubled by artists?

Wang Du declares: "I want to be the media, too. I want to be the journalist after the journalist." He produces sculptures based on media images which he reframes or whose original scale and centering he reproduces faithfully. His installation *Stratégie en chambre* (Armchair Strategy), 1999, is a gigantic, voluminous image that forces the viewer to traverse enormous piles of newspapers published during the conflict in Kosovo, a formless mass at the top of which emerge sculpted effigies of Bill Clinton, Boris Yeltsin, and other figures from press photos of the period, as well as a set of planes made of newspaper. The force of Wang Du's work stems from his capacity to give weight to the furtive images of the media: he quantifies what would conceal itself from materiality, restores the volume and weight of events, and colors general information by hand. Wang Du sells information by the pound. His storehouse of sculpted images invents an arsenal of communication, which duplicates the work of press agencies by reminding us that facts are also objects around which we must circulate. His work method might be defined as "corporate shadowing," i.e.,

mimicking or doubling professional structures, tailing and following them.

When Daniel Pflumm works with the logos of large companies like AT&T, he performs the same tasks as a communications agency. He alienates and disfigures these acronyms by "liberating their forms" in animated films for which he produces sound tracks. And his work is similar to that of a graphic design firm when he exhibits the still identifiable forms of a brand of mineral water or a food product in the form of abstract light boxes that evoke the history of pictorial modernism. "Everything in advertising," Pflumm explains, "from planning to production via all the conceivable middle-men, is a compromise and an absolutely incomprehensible complex of working steps."[03] According to him, the "actual evil" is the client who makes advertising a subservient and alienated activity, allowing for no innovation. By "doubling" the work of advertising agencies with his pirate videos and abstract signs, Pflumm produces objects that appear cut out of their context, in a floating space that has to do at once with art, design, and marketing. His production is inscribed within the world of work, whose system he doubles without caring about its results or depending on its methods. He is the artist as phantom employee.

In 1999, Swetlana Heger and Plamen Dejanov decided to devote their exhibitions for one year to a contractual relationship with BMW: they rented out their work force as well as their potential for visibility (the exhibitions to which they were invited), creating a "pirate" medium for the car company. Pamphlets, posters, booklets, new vehicles and accessories: Heger and Dejanov used all the objects and materials produced by the German manufacturer in the context of exhibitions. Pages of group exhibition catalogs that were reserved for them were

03 DANIEL PFLUMM, "ART AS INNOVATIVE ADVERTISING," INTERVIEW BY WOLF-GÜNTER THIEL, FLASH ART, NO. 209, NOVEMBER-DECEMBER 1999, PP. 78-81.

occupied by advertisements for BMW. Can an artist deliberately pledge his work to a brand name? Maurizio Cattelan was content to work as a middleman when he rented his exhibition space to a cosmetics manufacturer during the Aperto at the Venice Biennale. The resulting piece was called *Lavorare è un brutto mestiere* (Working is a Dirty Job), 1993. For their first exhibition in Vienna, Heger and Dejanov made a symmetrical gesture by closing the gallery for the duration of their show, allowing the staff to go on vacation. The subject of their work is work itself: how one person's leisure time produces another's employment, how work can be financed by means other than those of traditional capitalism. With the BMW project, they showed how work itself can be remixed, superimposing suspect images – as they are obviously freed from all market imperatives – on a brand's official image. In both cases, the world of work, whose forms Heger and Dejanov reorganize, is made the object of a postproduction.

And yet, the relations Heger and Dejanov established with BMW took the form of a contract, an alliance. Pflumm's untamed practice is situated on the margins of professional circuits, outside of any client-supplier relationship. His work on brands defines a world in which employment is not distributed according to a law of exchange and governed by contracts linking different economic entities, but in which it is left to the free will of each party, in a permanent potlatch that does not allow a gift in return. Work redefined in this way blurs the boundaries that separate it from leisure, for to perform a task without being asked is an act only leisure affords. Sometimes these limits are crossed by companies themselves, as Liam Gillick noted with Sony: "We are faced with a separation of the professional and the domestic that was created by electronic companies ... Tape recording, for example, only existed in the professional field during the forties, and people did not really know what they could use it for in everyday life. Sony blurred the professional and the domestic."[04] In 1979, Rank Xerox imagined transposing the world of the office to the

graphic interface of the microcomputer, which resulted in icons for "trash," "files," and "desktops." Steve Jobs, founder of Apple, took up this system of presentation for Macintosh five years later. Word processing would from now on be indexed to the formal protocol of the service industry, and the image-system of the home computer would be informed and colonized from the start by the world of work. Today, the spread of the home office is causing the artistic economy to undergo a reverse shift: the professional world is flowing into the domestic world, because the division between work and leisure constitutes an obstacle to the sort of employee companies require, one who is flexible and reachable at any moment.

1994: Rirkrit Tiravanija organized a lounge area in Dijon, France, for artists in the exhibition *Surface de réparation* (Penalty Zone) that included armchairs, a foosball table, artwork by Andy Warhol, and a refrigerator, allowing the artists to unwind during preparations for the show. The work, which disappeared when the show opened to the public, was the reverse image of the artistic work schedule.

With Pierre Huyghe, the opposition between entertainment and art is resolved in activity. Instead of defining himself in relation to work ("what do you do for a living?"), the individual in his exhibitions is constituted by his or her use of time ("what are you doing with your life?"). *Ellipse* (Ellipsis), 1999, features the German actor Bruno Ganz doing a pick-up shot between two scenes in Wim Wenders's *My American Friend,* shot twenty years earlier. Ganz walks a path that was merely suggested in the Wenders film: he fills in an ellipsis. But when is Bruno Ganz working and when is he off? While he was employed as an actor in *My American Friend,* is he still working twenty-one years later when he films a transitional shot between two scenes in

04 LIAM GILLICK, "WERE PEOPLE AS STUPID BEFORE TV?," INTERVIEW BY ERIC TRONCY, *DOCUMENTS SUR L'ART,* NO. 11, FALL-WINTER, 1997/1998, PP. 115-121.

Wenders's film? Isn't the ellipsis, in the end, simply an image of leisure, the negative space of work? While free time signifies "time to waste" or time for organized consumption, isn't it also simply a passage between two sequences?

"Posters," 1994, a series of color photographs by Huyghe, presents an individual filling in a hole in the sidewalk and watering the plants in a public square. But is there such a thing as a truly public space today? These fragile, isolated acts engage the notion of responsibility: if there is a hole in the sidewalk, why does a city employee fill it in, and not you or me? We claim to share a common space, but it is in fact managed by private enterprise: we are excluded from that scenario by erroneous subtitling, which appears beneath images of the political community.

Pflumm's images are the products of an analogous micro-utopia, in which supply and demand are disturbed by individual initiatives, a world where free time generates work, and vice versa, a world where work meets computer hacking. We know that some hackers make their way into hard drives and decode the systems of companies or institutions for the sake of subversion but sometimes also in the hopes of being hired to improve the security system: first they show evidence of their capacity to be a nuisance, then they offer their services to the organism they have just attacked. The treatment to which Pflumm subjects the public image of multinationals proceeds from the same spirit: work is no longer remunerated by a client, contrary to advertising, but distributed in a parallel circuit that offers financial resources and a completely different visibility. Where Heger and Dejanov position themselves as false providers of a service for the real economy, Pflumm visually blackmails the economy that he parasites. Logos are taken hostage, then placed in semi-freedom, as *freeware* that users are asked to improve on themselves. Heger and Dejanov sold a bugged application program to the company

whose image they propagated; Pflumm circulates images along with the "pilot," the source code that allows them to be duplicated.

When Pflumm makes a video using images taken from CNN (*CNN, Questions and Answers,* 1999), he switches jobs and becomes a programmer – a mode of production with which he is familiar through his activity as a DJ and musician.

The service industry aesthetic involves a reprocessing of cultural production, the construction of a path through existing flows; producing a service, an itinerary, within cultural protocols. Pflumm devotes himself to supporting chaos productively. While he uses this expression to describe his video projects in techno clubs, it may also be applied to the whole of his work, which seizes on the formal scraps and bits of code issued from everyday life in its mass media form, to construct a formal universe in which the modernist grid joins excerpts from CNN on a coherent level, that of the general pirating of signs.

Pflumm goes beyond the idea of pirating: he constructs montages of great formal richness. Subtly constructivist, his works are wrought by a search for tension between the iconographic source and the abstract form. The complexity of his references (historical abstractions, Pop art, the iconography of flyers, music videos, corporate culture) goes hand in hand with a great technical mastery: his films are closer to industry-standard videos than the average video art. Pflumm's work currently represents one of the most probing examples of the encounter between the art world and techno music.

Techno Nation has long distorted well-known logos on T-shirts: there are countless variations on Coca-Cola or Sony, filled with subversive messages or invitations to smoke Sinsemilla. We live in a world in which forms are indefinitely available to all manipulations, for better or worse, in which Sony and Daniel Pflumm cross paths in a space

saturated with icons and images.

As practiced by Pflumm, the mix is an attitude, an ethical stance more than a recipe. The postproduction of work allows the artist to escape the posture of interpretation. Instead of engaging in critical commentary, we have to experiment, as Gilles Deleuze asked of psychoanalysis: to stop interpreting symptoms and try more suitable arrangements.

HOW TO INHABIT GLOBAL CULTURE
(AESTHETICS AFTER MP3)

THE ARTWORK AS A SURFACE FOR DATA STORAGE

From Pop art to Minimalist and Conceptual art, the art of the sixties corresponds to the apex of the pair formed by industrial production and mass consumption. The materials used in Minimalist sculpture (anodized aluminum, steel, galvanized iron, Plexiglas, neon, and so on) reference industrial technology and particularly the architecture of giant factories and warehouses. The iconography of Pop art, meanwhile, refers to the era of consumption and particularly the appearance of the supermarket and the new forms of marketing linked to it: visual frontality, seriality, abundance.

The contractual and administrative aesthetic of Conceptual art marked the beginning of the service economy. It is important to note that Conceptual art was contemporary to the decisive advance of computer research in the early seventies: while the microcomputer appeared in 1975 and Apple II in 1977, the first microprocessor dates from 1971. That same year, Stanley Brouwn exhibited metal boxes containing cards that documented and retraced his itineraries (*40 Steps and 1000 Steps*), and Art & Language produced *Index 01,* a set of card files presented in the form of a Minimalist sculpture. On Kawara had already established his system of notation in files (his encounters, trips, and reading materials), and in 1971 he produced *One Million Years,* ten files that kept an account that went well beyond human bounds, and thus came closer to the colossal amounts of processing required by computers.

These works introduced data storage – the aridity of index card classification and the notion of the filing cabinet itself – into artistic practice: Conceptual art used computer protocol, still at its beginnings (the products in question would not truly make their public appearance until the following decade). In the late sixties, IBM emerged as a precursor in the field of immaterialization: controlling seventy percent of the computer market, International Business Machine

rechristened itself IBM World Trade Corporation and developed the first deliberately multinational strategy adapted to the global civilization to come. A runaway enterprise, its productive apparatus was literally unlocalizable, like a conceptual work whose physical appearance hardly matters and can be materialized anywhere. Doesn't a work by Lawrence Weiner, which may be produced or not produced by anyone, imitate the mode of production of a bottle of Coca-Cola? All that matters is the formula, not the place in which it is made or the identity of the person who makes it.

The configuration of knowledge that IBM ushered in was embodied in Tony Smith's *Black Box* (1963–65): an opaque block meant to process a social reality transformed into bits, through inputs and outputs. In his presentation folder, he pointed out that the IBM 3750, a silicon Big Brother, allows branches of a company in the same region to centralize all information indicating who has entered or exited which of the company's buildings, through what door, and at what hour ...

THE AUTHOR, THIS LEGAL ENTITY
Shareware does not have an author but a proper name. The musical practice of sampling has also contributed to destroying the figure of the Author, in a practical way that goes beyond theoretical deconstruction (the famous "death of the author" according to Barthes and Foucault). "I'm still pretty skeptical about the concept of the author," says Douglas Gordon, "and I'm happy to remain in the background of a piece like *24 Hour Psycho* where Hitchcock is the dominant figure. Likewise, I share responsibility for *Feature Film* equally with the conductor James Conlon and the musician Bernard Herrmann. ... In appropriating extracts from films and music, we could say, actually, that we are creating time readymades, no longer out of daily objects but out of objects that are a part of our culture."[01] The world of music has made the explosion of the protocol of authorship banal, particularly with "white labels," the 45s typical of DJ culture, made in

limited editions and distributed in anonymous record jackets, thus escaping industry control. The musician-programmer realizes the ideal of the collective intellectual by switching names for each of his or her projects, as most DJs have multiple names. More than a physical person, a name now designates a mode of appearance or production, a line, a fiction. This logic is also that of multinationals, which present product lines as if they emanated from autonomous firms: based on the nature of his products, a musician such as Roni Size will call himself "Breakbeat Era" or "Reprazent," just as Coca-Cola or Vivendi Universal owns a dozen or so distinct brands which the public does not think to connect.

The art of the eighties criticized notions of authorship and signature, without however abolishing them. If buying is an art, the signature of the artist-broker who carried out the transactions retained all its value, indeed guaranteed a successful and profitable exchange. The presentation of consumer products was organized in stylized configurations: Jeff Koons's *Hoovers* were immediately distinguishable from Haim Steinbach's shelves, the way two boutiques that sell similar products distinguish themselves by their art of display.

Among the artists directly questioning the notion of the signature are Mike Bidlo, Elaine Sturtevant, and Sherrie Levine, whose works rely on a common method of reproducing works of the past, but via very different strategies. When he exhibited an exact copy of a Warhol painting, Bidlo entitled it *Not Duchamp (Bicycle Wheel,* 1913). When Sturtevant exhibited a copy of a Warhol painting, she kept the original title: *Duchamp, coin de chasteté,* 1967. Levine, meanwhile, got rid of the title in favor of a reference to a temporal shift in the series "Untitled (*After* Marcel Duchamp)." For these three artists, the issue

01 DOUGLAS GORDON, "A NEW GENERATION OF READYMADES," INTERVIEW BY CHRISTINE VAN ASSCHE, *ART PRESS*, NO. 255, MARCH 2000, PP. 27-32.

is not to make use of these works but to re-exhibit them, to arrange them according to personal principles, each creating a "new idea" for the objects they reproduce, based on the Duchampian principle of the reciprocal readymade. Bidlo constructs an ideal museum, Sturtevant constructs a narrative by reproducing works showing radical moments in history, while Levine's copyist work, inspired by Roland Barthes, asserts that culture is an infinite palimpsest. Considering each book to consist of "multiple writings, proceeding from several cultures and entering into dialogue, into parody, into protest," Barthes accords the writer the status of scriptor, an intertextual operator: the only place where this multiplicity of sources converges is in the brain of the reader-postproducer.[02] In the early twentieth century, Paul Valéry thought that one might be able to write "a history of the mind as it produces or consumes literature ... without ever uttering the name of a writer."[03] Since we write while reading, and produce artwork as viewers, the receiver becomes the central figure of culture to the detriment of the cult of the author.

In the sixties, the notion of the "open work" (Umberto Eco) opposed the classic schema of communication that supposed a transmitter and a passive receiver. Nevertheless, while the open work (such as an interactive or participatory Happening by Allan Kaprow) offers the receiver a certain latitude, it only allows him or her to react to the initial impulse provided by the transmitter: to participate is to complete the proposed schema. In other words, "the participation of the spectator" consists of initialing the aesthetic contract which the artist reserves the right to sign. That is why the open work, for Pierre Lévy, "still remains caught in the hermeneutic paradigm," since the receiver is only invited "to fill in the blanks, to choose between possible meanings."

02 ROLAND BARTHES, "THE DEATH OF THE AUTHOR" IN *THE RUSTLE OF LANGUAGE*, TRANS. RICHARD HOWARD (NEW YORK: HILL AND WANG, 1986). P. 54.

03 PAUL VALÉRY, *CAHIERS*, VOL. 1 (PARIS: BIBLIOTHÈQUE DE LA PLÉIADE, EDITIONS GALLIMARD, 1973).

Lévy contrasts this "soft" conception of interactivity with the enormous possibilities that cyberspace now offers: "the emerging technocultural environment encourages the development of new types of art that ignore the separation between transmission and reception, composition and interpretation."[04]

ECLECTICISM AND POSTPRODUCTION

The Western world – through its museum system and its historical apparatus as well as its need for new products and new atmospheres – has ended up recognizing traditions thought doomed to disappearance in the advance of industrial modernism as cultures in themselves, accepting as art what was once only perceived as folklore or savagery. Remember that for a citizen at the start of the century, the history of sculpture went from Ancient Greece to the Renaissance and was restricted to European names. Global culture today is a giant anamnesis, an enormous mixture whose principles of selection are very difficult to identify.

How can we prevent this telescoping of cultures and styles from ending up in kitsch eclecticism, a cool Hellenism excluding all critical judgment? We generally describe taste as "eclectic" when it is uncertain or lacks criteria, a spiritless intellectual process, a set of choices that establishes no coherent vision. By considering the adjective "eclectic" pejorative, common parlance accredits the idea that one must lay claim to a certain type of art, literature, or music, or else be lost in kitsch, having failed to assert a sufficiently strong – or, quite simply, locatable – personal identity. This shameful quality of eclecticism is inseparable from the idea that the individual is socially assimilated to his or her cultural choices: I am supposed to be what I read, what I listen to, what I look at. We are identified by our personal

04 PIERRE LÉVY, *L'INTELLIGENCE COLLECTIVE. POUR UNE ANTHROPOLOGIE DU CYBERSPACE* (PARIS: LA DÉCOUVERTE, 1994), P. 123.

strategy of sign consumption, and kitsch represents outside taste, a sort of diffuse and impersonal opinion substituted for individual choice. Our social universe, in which the worst flaw is to be impossible to situate in relation to cultural norms, urges us to reify ourselves. According to this vision of culture, what each person might do with what he or she consumes does not matter; so the artist may very well make use of a terrible soap opera and form a very interesting project.

The anti-eclectic discourse has therefore become a discourse of adherence, the wish for a culture marked out in such a way that all its productions are tidily arranged and clearly identifiable, like badges or rallying signs of a vision of culture. It is linked to the constitution of the modernist discourse as set forth in the theoretical writings of Clement Greenberg, for whom the history of art constitutes a linear, teleological narrative in which each work is defined by its relations to those that precede and those that follow. According to Greenberg, the history of modern art can be read as a gradual "purification" of painting and sculpture and the contraction of their subject to their formal properties. Piet Mondrian thus explained that neo-plasticism was the logical consequence – and suppression – of all art that preceded it. This theory, which envisages the history of art as a duplication of scientific research, has the added effect of excluding non-Western countries, considered "unhistorical" and unscientific. It is this obsession with the "new" (created by this vision of historicist art centered on the West) that one of the protagonists of the Fluxus movement, George Brecht, mocked, explaining that it is much more difficult to be the ninth person to do something than to be the first, because then you have to do it very well.

In Greenberg and in many Western histories of art, culture is linked to this monomania that considers eclecticism (that is, any attempt to exit this purist narrative) a cardinal sin. History *must make sense*. And this sense must be organized in a linear narrative.

In an essay published in 1987, "Historisation ou intention: le retour d'un vieux débat" (Historicization or Intention: The Return of an Old Debate), Yve-Alain Bois engaged in a critical analysis of postmodern eclecticism such as it was manifested in the works of the European neo-expressionists and painters such as Julian Schnabel and David Salle. Bois summed up these artists' positions as such: Being freed from history, they might have recourse to history as a sort of entertainment, treating it as a space of pure irresponsibility. Everything from now on had the same meaning for them, the same value. In the early eighties, the trans-avant-garde struggled with a logic of bric-a-brac and the flattening of cultural values in a sort of international style that blended Giorgio de Chirico and Joseph Beuys, Jackson Pollock and Alberto Savinio, completely indifferent to the content of their works and their respective historical positions. At around the same time, Achille Bonito Oliva supported the trans-avant-garde artists in the name of a "cynical ideology of the traitor," according to which the artist would be a nomad circulating as he pleased through all periods and styles, like a vagabond digging through a dump in search of something to carry away. This is precisely the problem: under the brush of a Schnabel or an Enzo Cucchi, the history of art is like a giant trash can of hollow forms, cut off from their meaning in favor of a cult of the artist/demiurge/salvager under the tutelary figure of Picasso. In this vast enterprise of the reification of forms, the metamorphosis of the gods finds kinship with the museum without walls. Such an art of citation, practiced by the neo-fauves, reduces history to the value of merchandise. We are then very close to the "equivalence of everything, the good and the bad, the beautiful and the ugly, the insignificant and the distinctive" which Flaubert made the theme of his last novel, and whose coming he feared in Scénarios pour Bouvard et Pécuchet.

Jean-François Lyotard could not bear the confusion between the postmodern condition such as he theorized it and the so-called postmodernist art of the eighties: to mix neo- or hyper-realist motifs on

91

the same surface with abstract, lyrical, or conceptual motifs was to signify that everything was equal because everything could be consumed. He felt that eclecticism solicited the habits of the magazine reader, the needs of the consumer of mass produced images, the mind of the supermarket shopper.[05] According to Yve-Alain Bois, only the historicization of forms can preserve us from cynicism and a leveling of everything. For Lyotard, eclecticism diverts artists from the question of what is "unpresentable," a major concern, since it is the guarantee of a tension between the act of painting and the essence of painting: if artists give in to the eclecticism of consumption, they serve the interests of the techno-scientific and post-industrial world and shirk their critical duties.

But can't this eclecticism, this banalizing and consuming eclecticism that preaches cynical indifference toward history and erases the political implications of the avant-gardes, be contrasted with something other than Greenberg's Darwinian vision, or a purely historicizing vision of art? The key to this dilemma is in establishing processes and practices that allow us to pass from a consumer culture to a culture of activity, from a passiveness toward available signs to practices of accountability. Every individual, and particularly every artist, since he or she evolves among signs, must take responsibility for forms and their social functioning: the emergence of a "civic consumption," a collective awareness of inhuman working conditions in the production of athletic shoes, for example, or the ecological ravages occasioned by various sorts of industrial activity is each an integral part of this notion of accountability. Boycotts, *détournement,* and piracy belong to this culture of activity. When Allen Ruppersberg recopied Oscar Wilde's *The Portrait of Dorian Gray* on canvas (1974), he took a literary text and considered himself responsible for it: he rewrote it.

05 SEE JEAN-FRANÇOIS LYOTARD, *THE POSTMODERN EXPLAINED*, TRANS. DON BARRY, ET AL.

(MINNEAPOLIS: UNIVERSITY OF MINNESOTA PRESS, 1993).

When Louise Lawler exhibited a conventional painting of a horse by Henry Stullmann (lent by the New York Racing Association) and placed it under spotlights, she asserted that the revival of painting, in full swing at the time (1978), was an artificial convention inspired by market interests.

To rewrite modernity is the historical task of this early twenty-first century: not to start at zero or find oneself encumbered by the store-house of history, but to inventory and select, to use and download.

Fast-forward to 2001: collages by the Danish artist Jakob Kolding rewrite the constructivist works of Dada, El Lissitzky, and John Heartfield while taking contemporary social reality as their starting point. In videos or photographs, Fatimah Tuggar mixes American advertisements from the fifties with scenes from everyday life in Africa, and Gunilla Klingberg reorganizes the logos of Swedish supermarkets into enigmatic mandalas. Nils Norman and Sean Snyder make cata-logs of urban signs, rewriting modernity starting with its common usage in architectural language. These practices each affirm the im-portance of maintaining activity in the face of mass production. All its elements are usable. No public image should benefit from impunity, for whatever reason: a logo belongs to public space, since it exists in the streets and appears on the objects we use. A legal battle is underway that places artists at the forefront: no sign must remain inert, no image must remain untouchable. Art represents a counter-power. Not that the task of artists consists in denouncing, mobilizing, or protesting: all art is engaged, whatever its nature and its goals. Today there is a quarrel over representation that sets art and the official image of reality against each other; it is propagated by adver-tising discourse, relayed by the media, organized by an ultralight ideology of consumption and social competition. In our daily lives, we come across fictions, representations, and forms that sustain this collective imaginary whose contents are dictated by power. Art puts

us in the presence of counterimages, forms that question social forms. In the face of the economic abstraction that makes daily life unreal, or an absolute weapon of techno-market power, artists reactivate forms by inhabiting them, pirating private property and copyrights, brands and products, museum-bound forms and signatures. If the downloading of forms (these samplings and remakes) represents important concerns today, it is because these forms urge us to consider global culture as a toolbox, an open narrative space rather than a univocal narrative and a product line. Instead of prostrating ourselves before works of the past, we can use them. Like Rirkrit Tiravanija inscribing his work within Philip Johnson's architecture, like Pierre Huyghe refilming Pier Paolo Pasolini, works can propose scenarios and art can be a form of using the world, an endless negotiation between points of view.

It is up to us as beholders of art to bring these relations to light. It is up to us to judge artworks in terms of the relations they produce in the specific contexts they inhabit. Because art is an activity that produces relationships to the world and in one form or another makes its relationships to space and time material.